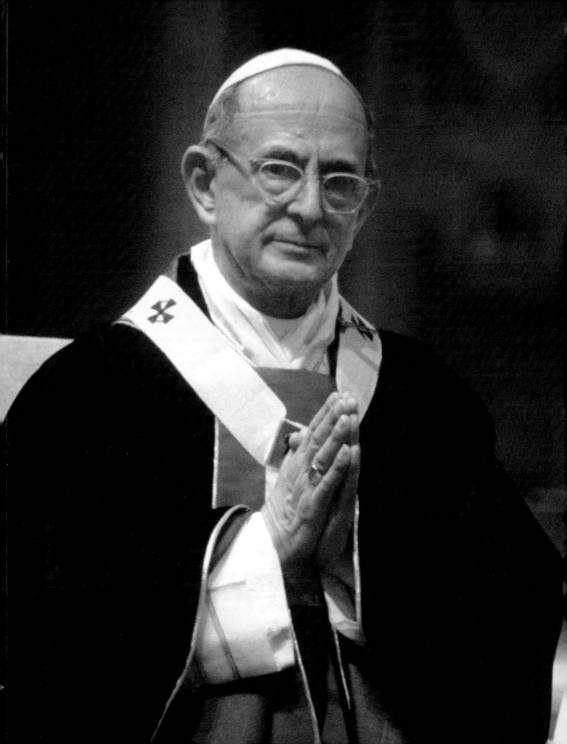

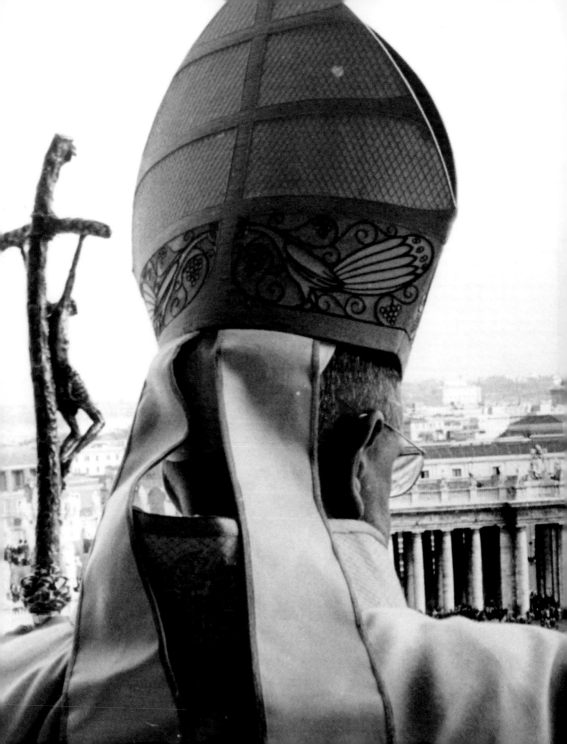

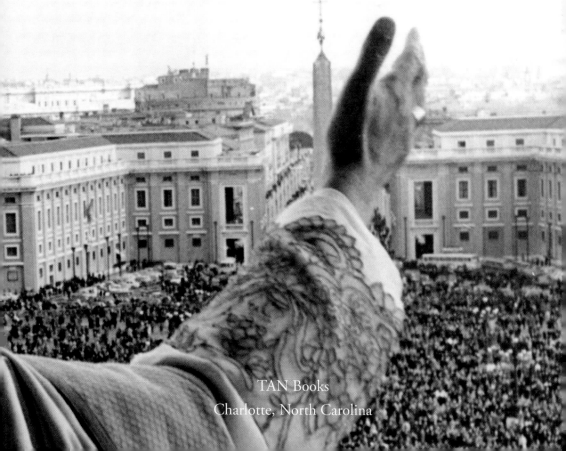

POPE SAINT PAUL VI

A Pictorial Retrospective

Karl A. Schultz

TAN Books
Charlotte, North Carolina

Cover and interior design by Caroline K. Green

Library of Congress Control Number: 2018956831

ISBN: 978-1-5051-1271-9

Published in the United States by
TAN Books
PO Box 410487
Charlotte, NC 28241
www.TANBooks.com

Printed and Bound in the United States of America

DEDICATION

To my mother, with love and appreciation for inculcating in me, in words, but above all in her faithful attitudes and actions, an enduring love for the family, one's neighbor, and the Church, and an appreciation of the blessings bestowed by the Holy Spirit in Vatican II and in the pontificate of Pope St. Paul VI. Thank you, Mom, I miss and love you. Karl

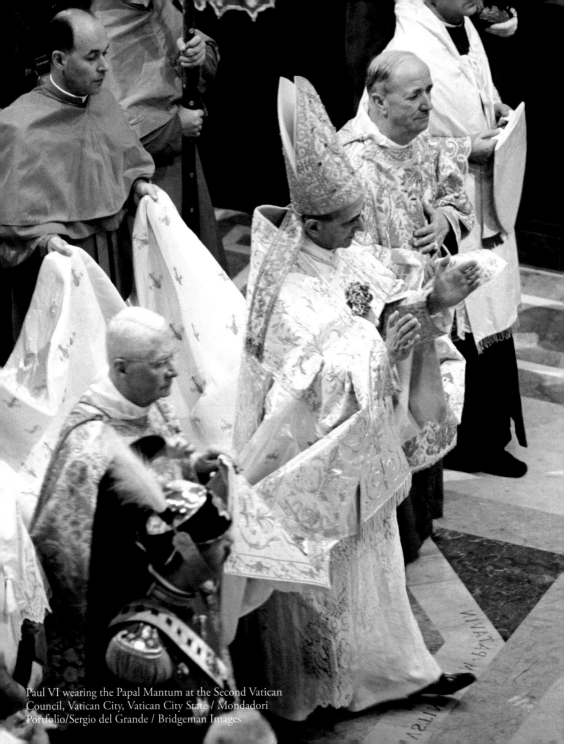

Paul VI wearing the Papal Mantum at the Second Vatican Council, Vatican City, Vatican City State / Mondadori Portfolio/Sergio del Grande / Bridgeman Images

Contents

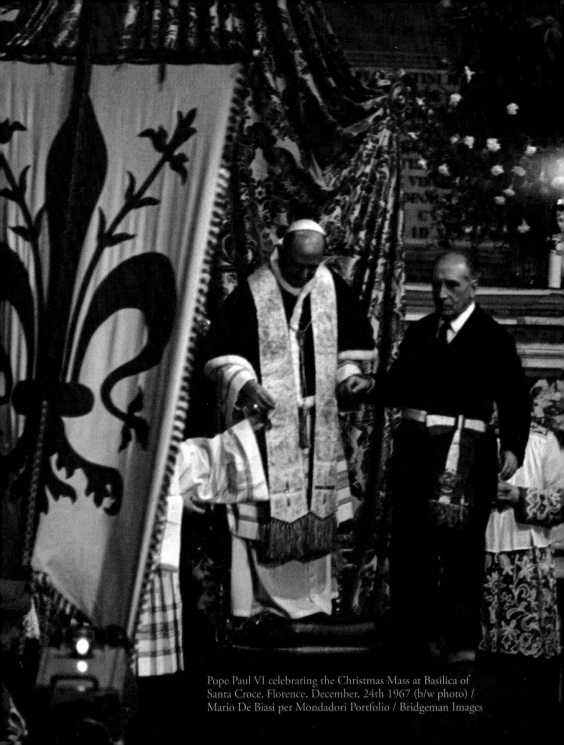

Pope Paul VI celebrating the Christmas Mass at Basilica of
Santa Croce, Florence, December, 24th 1967 (b/w photo) /
Mario De Biasi per Mondadori Portfolio / Bridgeman Images

Acknowledgments

I am very grateful to Fr. Tim Fitzgerald, CP, for his help and feedback on all of my books and my speaking and writing projects and initiatives for so many years. I treasure our discussions of St. Paul VI, the video dialogue on him that we produced, and our shared appreciation for the great leadership, inspiration, and service that he provided for the Church. Thanks also to the Commodore, Señor Neal Murphy, for helping me navigate the unpredictable waters of publishing and life and for likewise reflecting with me on the implications of St. Paul VI's ministry, life witness, and teachings for my own life and that of the Church.

Thanks also to my editor, John Moorehouse, for his flexibility, confidence, support, good humor, and distinctive contributions.

Thanks most of all, and love, to my dad for all he has done for me, and to Marc (Muggy), Brian, Andy, and Big T (Uncle Tom). I am blessed to have shared joyfully with you in the fruits and uplifting challenges of Pope St. Paul VI's pontificate and Vatican II.

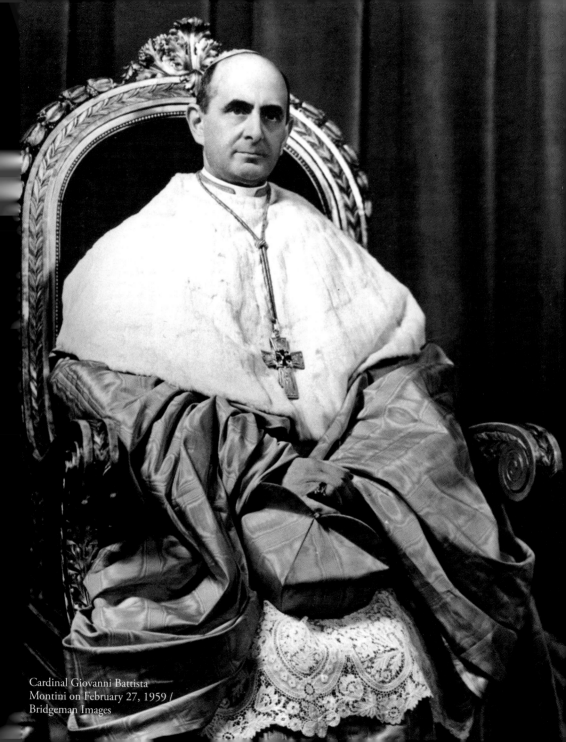

Timeline

SEPTEMBER 27, 1897
Giovanni Battista Montini is born in Brescia, Italy.

SEPTEMBER 30, 1897
Baptized by Fr. Giovanni Fiorini at Pieve di Concesio.

1916–1920
Day student at the diocesan seminary of Brescia.

MAY 29, 1920
Ordained priest by Bishop Giacinto Gaggia at the cathedral of
Brescia.

MAY 30, 1920
First Mass at the Shrine of Our Lady of Graces, Brescia.

DECEMBER 9, 1922
Degree in canon law at the law faculty of the seminary of Milan.

MAY–OCTOBER 1923
Worked at the Apostolic Nunciature of Warsaw.

OCTOBER 1924

Joins the Vatican Secretariat of State.

DECEMBER 13, 1937

Appointed Substitute Secretary of State and Secretary of the Cipher.

1939–1945

Oversaw the Vatican Information Office for the exchange and search for news of military and civilian prisoners.

AUGUST 1951

Tour of North American cities: Washington, Denver, Chicago, Detroit, Pittsburgh, New York, and Quebec.

NOVEMBER 29, 1952

Nominated Pro-Secretary of State for Ordinary Affairs.

NOVEMBER 1, 1954

Nominated Archbishop of Milan.

NOVEMBER 5–24, 1957

Organized and oversaw the 'Great Mission in Milan.' It consisted of 1,288 preachers, including 24 archbishops and bishops, giving 15,000 conferences in 410 locations. It received worldwide attention and acclaim.

DECEMBER 15, 1958

Made cardinal at the first Consistory of St. John XXIII, after being first on the list announced.

JUNE 3–16, 1960

Another trip to various US cities, and then to Brazil. Along with President Eisenhower, receives an honorary degree in law from

Notre Dame. Receives an honorary degree in social sciences from the Pontifical Catholic University of Rio de Janeiro.

JUNE 21, 1963

Elected pope on the fifth ballot and takes the traditional name Paul in honor of the Apostle to the Gentiles and as a change from recent papal names.

JUNE 30, 1963

Coronation as pope in St. Peter's Square.

SEPTEMBER 29, 1963

Opens second session of Vatican II.

DECEMBER 4, 1963

Concludes second session with promulgation of the Constitution on the Sacred Liturgy and the Decree on Social Communication.

JANUARY 4–6, 1964

Pilgrimage to the Holy Land. Meets and embraces Patriarch Athenagoras I.

MAY 7, 1964

Address to artists in the Sistine Chapel.

AUGUST 6, 1964

Publication of first encyclical which set the tone for the council and his pontificate, *Ecclesiam Suam.*

SEPTEMBER 14, 1964

Gives speech at the opening of the pivotal third session of the council.

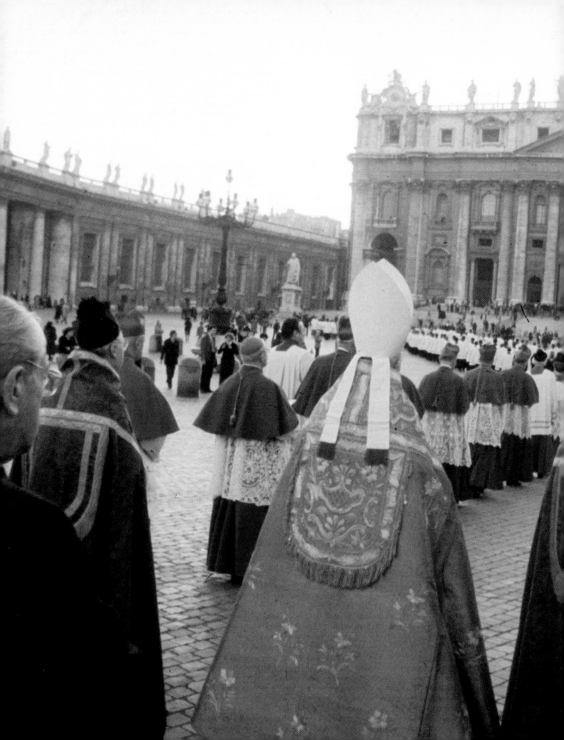

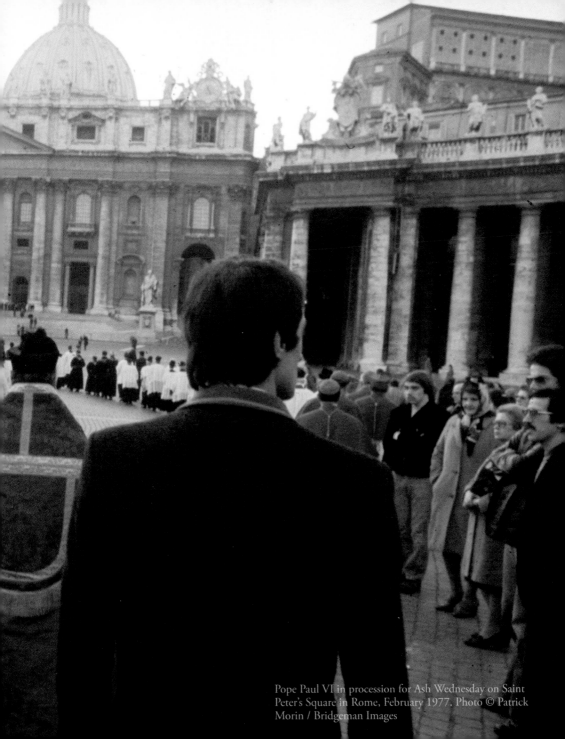

Pope Paul VI in procession for Ash Wednesday on Saint Peter's Square in Rome, February 1977. Photo © Patrick Morin / Bridgeman Images

NOVEMBER 13, 1964

Places the tiara on the altar of St. Peter and donates it to the poor. A gift from Catholics in Milan in anticipation of his coronation as pope, it was bought by the Catholic Church in America in 1968 at the behest of Cardinal Spellman, and is displayed between Memorial Hall and the Crypt Church at the Crypt level of the Basilica of the Immaculate Conception in Washington, DC.

DECEMBER 2–5, 1964

Pilgrimage to Mumbai for the 38th International Eucharistic Congress.

SEPTEMBER 3, 1965

Publication of encyclical on the Eucharist, *Mysterium Fidei.*

OCTOBER 4, 1965

One day, whirlwind trip to New York City capped by a memorable speech at the United Nations and a Mass for peace at Yankee Stadium.

DECEMBER 7, 1965

Mutual lifting of excommunications by the pope and the patriarch of Constantinople—removing "from both the memory and the midst of the Church the sentences of excommunication."

DECEMBER 8, 1965

Concludes the Second Vatican Council in St. Peter's Square. Messages of the council to various groups are read by representatives of those groups (e.g., government officials, scholars, scientists, artists, women, workers, the poor, the sick, the suffering, and the young).

MARCH 26, 1967

Publication of the encyclical *Populorum Progressio* to great acclaim.

MAY 7, 1967

Celebrates the first World Day of Social Communication.

JUNE 24, 1967

Publication of an encyclical on priestly celibacy, *Sacerdotalis Caelibatus.*

JUNE 29, 1967

Inaugurates a Year of Faith.

JULY 25–26, 1967

Visits Patriarch Athenagoras I in Turkey.

OCTOBER 26–28, 1967

Receives Patriarch Athenagoras I in the Vatican.

JANUARY 1, 1968

Celebration of the first world day of peace.

JUNE 30, 1968

Concludes the Year of Faith with the promulgation of the *Credo of the People of* God, interspersed throughout this book.

JULY 25, 1968

Publication of the encyclical *Humanae Vitae.*

AUGUST 22–25, 1968

Trip to Bogota, Columbia for the 39th International Eucharistic Congress and the Conference of Latin American bishops.

JULY 31–AUGUST 2, 1969

Pilgrimage to Uganda, the first visit of a pope to Africa.

NOVEMBER 30, 1969

The new rite of the Mass is inaugurated.

SEPTEMBER 27, 1970

Proclamation of St. Teresa of Avila as the first female Doctor of the Church.

OCTOBER 4, 1970

Proclamation of St. Catherine of Siena as a Doctor of the Church.

MAY 14, 1971

Publication of *Octogesima Adveniens,* an elaboration and localization of *Populorum Progressio,* as a letter to Cardinal Maurice Roy on the eightieth anniversary of *Rerum Novarum.*

JUNE 29, 1971

Publication of *Evangelica Testificatio,* an apostolic exhortation on the renewal of religious life.

JUNE 30, 1971

Inauguration of Nervi Hall, later named Paul VI Hall by St. John Paul II, where the pope gives his Wednesday public audiences.

JUNE 23, 1973

Opening of the modern art wing of the Vatican Museum.

DECEMBER 2, 1973

Publication of *Ordo Paenitentiae,* the new rite of Penance, which included the option of face-to-face confession.

FEBRUARY 2, 1974

Publication of *Marialis Cultus,* an apostolic exhortation on the right ordering of devotion to Mary.

DECEMBER 8, 1974

Publication of *Paterna cum benevolentia,* an apostolic exhortation on reconciliation within the Church.

DECEMBER 24–25

Inaugurates the Holy / Jubilee Year with the opening of the Holy Door in St. Peter's. Inspired by this celebration, the pope decided that evening to write a letter on Christian joy.

MAY 9, 1975

Publication of an apostolic exhortation on Christian joy, *Gaudete in Domini.* Paul VI was inspired to write it after the liturgy on the evening of the opening of the Jubilee Year of 1975.

DECEMBER 8, 1975

Publication of the pope's last major document, and arguably his most influential and enduring, *Evangelii Nuntiandii.*

DECEMBER 16, 1975

Kisses the feet of Metropolitan Meliton of Chalcedon. Two days later, the Patriarch of Constantinople, Athenagoras I, hailed the "spontaneous symbolic act" of the pope as "an act without precedent in the history of the Church. . . . By this expressive sign our beloved brother the most venerable Pope of Rome . . . has shown to the Church and the world what a bishop, and above all the first Bishop of Christendom, can be, namely a force for reconciliation and for the unification of the Church and the world."

APRIL 21, 1978

Public release of his letter to the Red Brigades urging the release of the kidnapped former prime minister of Italy, Aldo Moro.

MAY 13, 1978

Prayer for Aldo Moro at the memorial Mass celebrated by Cardinal Poletti at the mother church, St. John Lateran.

JUNE 29, 1978

Final homily at St. Peter's Basilica in which he movingly summarizes his pontificate and cites and identifies with the words of St. Paul in 2 Tm 4:7: "I have fought the good battle, run the race and kept the faith." His affirmation is an inspirational challenge to conduct ourselves likewise.

AUGUST 3, 1978

Final private audience with Italian President Allesandro Pertini.

AUGUST 6, 1978

Surrounded by his secretaries, nearby kin, and closest associates, the pope dies at 9:40 p.m. of a massive heart attack. His venerable Polish alarm clock goes off at the wrong time, perhaps ominously signaling his death.

AUGUST 12, 1978

Funeral Mass at St. Peter's Basilica followed by burial in a simple plot in the Vatican Crypt.

*The book *Paul VI: The Man and His Message* by Monsignor Pasquale Macchi cited in the bibliography was a source for much of the information included in this timeline.

Foreword

I enjoy paging through my photo album. The pictures keep my past part of the present, thereby making sense of the seemingly scattered skeins of my life. Some see looking at pictures as aimless meandering down memory lane and as favorably praising the past compared to the present. The good old days, we say.

However, thoughtful gazing makes us realize the foolishness of forgetting our past, as though in hidden compartments it does not affect us. There is no past or present in God. God always works in the present. This pictorial retrospective of Paul VI at the time of his canonization by Pope Francis sharply reminds us how this frail, scholarly holy father made such an impact on the Church in his own day and, even more, challenges us today.

As we follow Paul VI's pictorial life, Karl Schultz accompanies his journey with a penetrating analysis of a man of God and of a great spiritual leader in the rapidly changing world of the '60s and '70s. Schultz has spent a good part of his life as a writer, lecturer, and enthusiastic promoter of the significance and legacy of Paul VI. He deftly comments on remarkable photos through Paul's early life, his early diplomatic career,

Secretary of State for Pope Pius XII, archbishop of Milan, and finally, his election as pope and his many travels.

Schultz examines the steady impress of Paul's desire to have the Church go on the offensive in a dialogical conversation within the Church, with other Christian communities, with other religions, and with the secular world. This serene thrust for dialogue is seen in his skillfully planned trips and talks illustrating his basic message of peace. Look deeply at Paul's face and open-arm gestures. The shy reserve of his early trips gives way to a determined desire to use his great potential as a spiritual leader. We see his tears at the squalor in Mumbai. We capture his resignation after the attempt on his life at the Manila airport. We are gripped by his steely resolve at the United Nations: "No more war! No more war!" We love the smile of happiness for all people in the Mass he celebrated at Yankee Stadium. We mourn with him at the funeral of his dear, assassinated friend, Aldo Moro.

In these pictures is a history of all of us living in a world and Church more distressed and further from peace than ever. Now as St. Paul VI, he looks at us in these photos with the challenge to take up the great mission of Jesus, the crucified peacemaker to whom he offered up his own life. He charges us: No more war; work for peace and justice for all the little crucified ones everywhere; and, above all, remember that God is Love as we work toward a civilization of love!

Fr. Timothy Fitzgerald, CP, STD
August 20, 2018

Introduction

A pictorial retrospective on Pope St. Paul VI is particularly fitting because he was able to communicate and illustrate the Faith prophetically, in a timely and timeless manner. He did this through powerful images and gestures that, along with his message and character, endure. He continues to influence and inspire not only his successors but those who have been touched by his person and ministry.

Pictures associated with Paul VI can express so much because he was decisively involved in so many pivotal events in his times—even though he was criticized for being timid and vacillating. Although he was neither colorful nor charismatic in public, he nonetheless conveyed powerful images and made vivid impressions through his words and deeds.

Visio Divina

The pictures can remind us of the times, places, and persons, and evoke various responses in us, such as nostalgia, gratitude, sadness, and praise, which in turn can serve as inspiration for reflection and prayer. The term *visio divina* is used to describe the contemplative experiencing of praying with icons, pictures, or biblical images, utilizing the various steps

of lectio divina (reading / listening, meditation, prayer, contemplation, and action) in tandem with our imagination. The sensate dimensions of *lectio* make *visio* a natural outgrowth and complementary spiritual practice.

Paul's aptitude for the timely symbolic gesture, pregnant with meaning and possibilities, makes this application even more suitable. Combine it with Paul's teachings, generously excerpted in this book, and you have a synthesis of *lectio* and *visio* that is both powerful and accessible. If a picture can convey a thousand words, this is all the more true of those involving Paul VI, because of his inspired authority and ministry, affinity for meaningful gestures, aptness with words, dialogical sensitivity to his audience, and profound spirituality and prophetic insight. For example:

- He dispensed communion to impoverished children on his knees.
- He gave one of the most memorable speeches in the history of the United Nations.
- He brought ninety thousand persons to their feet at Yankee Stadium, more than Babe Ruth, Joe DiMaggio, or Mickey Mantle ever did! The Beatles could only manage fifty-five thousand at nearby Shea Stadium two months before.
- He embarrassed a holy man, Cardinal Luciani, by placing the papal stole on him, unknowingly yet prophetically designating his successor.
- Less than three months before his own death, he gave a moving meditation and lamentation at a memorial Mass that consoled a grieving nation.

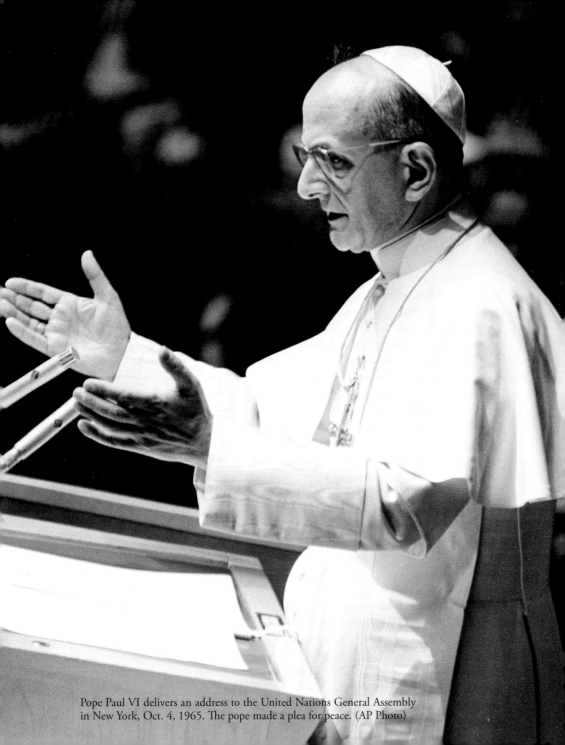

Pope Paul VI delivers an address to the United Nations General Assembly in New York, Oct. 4, 1965. The pope made a plea for peace. (AP Photo)

Drink in the images and words of this book, ponder the memories and associations they evoke, and bring them to prayer and contemplation. And now we can invoke the intercession of the subject and source of what follows, Pope St. Paul VI.

Collegiality and Subsidiarity

Paul didn't implement the Second Vatican Council, lead the Church, or reach out to the world by himself. He facilitated and supported the ministry and growth of many persons, often in subtle ways and behind the scenes. He encountered people and affected them, leaving an indelible impression. He conveyed the image of a pope in dialogue, in relationship. He had an instinct and predilection for encouraging, empowering, collaborating, and getting out of the way.

Paul's Grand Stages

Pictorial images abound of Paul VI at the closing of the council offering uplifting exhortations and prayers, and delegating specific vocational messages to others, reminding us that in the life of the Christian there is no room for individualism or pessimism. In the wave of the abuses that followed the conciliar reforms, he too became disillusioned and spoke of "the smoke of Satan" infiltrating the Church, but he persevered with his message and ministry in a spirit of hope and joy.

Paul's one-day sojourn to New York City on October 4, 1965 remains the most intensely documented and marketed papal journey in history. A plethora of books, magazine accounts, and even a record album were generated by this whirlwind visit. Over a half-century later, these continue to circulate in used media forums. This book is in that tradition, but it chronicles a lifetime and a pontificate rather than a day!

Coming on the heels of his historic trips to the Holy Land and India, this was uncharted territory for the papacy, and it is no wonder that he became known as the pilgrim pope.

A Renaissance Man and Pope

There are so many aspects to Paul's personality and personal journey. First and always, he was a disciple and son of the Church; then, a student, mentor, writer, teacher, diplomat, leader, administrator, and facilitator. The words and pictures of this book seek to reflect and depict, however briefly, each of these dimensions of his life and ministry.

Paul's captivating presence shines through the pictures and the narration. Like his apostolic namesake (cf. 2 Cor 10:10), he was neither physically nor verbally imposing, but as he himself said, on November 25, 1970, someone always listens, even if many laughed or said—as they did to St. Paul himself at the Areopagus—we will hear you another time (cf. Acts 17:32).

Not deterred, the pope who wrote insightfully on dialogue, joy, and evangelization lived what he taught, and his message and example lives on in his spiritual children.

Composition, Structure, and Scope

Finding ideas, subjects, and sources for pictures was the easiest part of compiling this book. Capturing Paul's life, teachings, and papacy in a concise and palatable manner was the real challenge.

Of necessity, the following account is selective and evocative. I focused on those things I deemed most important and relevant from what I knew about and from Paul VI, and their ramifications. Because he conveyed the Gospel without varnish and addressed controversial

issues in a counter-cultural way, his words and decisions clash with secu-lar and sectarian/ideological sensibilities. The truth hurts and heals, and Paul was an inspired dispenser of truth.

Because numerous chapters would interrupt the fluidity of the pic-tures and narration, the book is divided into four organic sections: His life, papacy, teachings, and times and legacy. The richness, practical and prophetic nature, and contemporary relevance of his teachings resulted in that being the longest section. Additionally, his magnificent, but sadly overlooked, motu propio *Credo of the People of God*, a modern fleshed-out restatement of the Creed, is presented in its entirety in easily distin-guished sections throughout the book. Its pictorial backdrop and the pervasiveness of biblical references and applications make it particularly conducive to lectio and visio divina. The book as a whole is composed to be read in the dialogical manner associated with Paul.

The best way to bring this prophetic and saintly pope to life is to observe, engage, heed, and emulate him according to our capabilities and circumstances. As his namesake said, *imitate me as I imitate Christ* (cf. 1 Cor 11:1).

PAUL'S PRESERVED AND PROPHETIC LEGACY

The official repository for Paul VI archives and mementos is the *Istituto Paolo VI* in Brescia, Italy, his hometown. His definitive biography, *Paul VI: The First Modern Pope* by Peter Hebblethwaite, contains a wealth of information about every aspect of Paul VI's life and papacy, and is an enjoyable read as well. A revised edition was published in the fall of 2018 after being out of print for almost two decades. One can also go online to find used copies of biographies of Paul VI that were published in the 1960s. Just put Paul VI in the subject heading and you'll be exposed to a

Pope Paul VI greeting the believers in front of the Basilica of Santa Croce before the Christmas Mass, Florence, December 24th, 1967 (b/w photo) / Mario De Biasi per Mondadori Portfolio / Bridgeman Images

variety of resources. I have three other books published on Paul VI, and they are listed in my bibliography at the end of the book.

This book focuses on Paul's teachings, initiatives, decisions, difficulties, achievements, and primary papal themes, and the ways they have prophetically retained their relevance almost a half century later. My objective is to bring to life one of the most influential and interesting Catholics of the twentieth century, a man who could rightly be referred to as the father of the modern Church. Hebblethwaite alludes to that in referring to him as the first modern pope.

Ever the Diplomat

Paul VI helped the Church engage the modern world without betraying or compromising Tradition, the sacred deposit of faith. Problems arose because of mistakes and faults on both sides, but the world took a dramatic turn away from Judeo-Christian values even more than could have been foreseen at the inception of the council, when the growing

materialism, secularism, and hedonism of society was already apparent. This is evident in the writings and comments of Paul VI and other Church leaders (most notably Venerable Fulton J. Sheen, who like the pope had powerful opponents and detractors inside the Church, but suffered in silence and without scandal), as well as insightful social commentators and theologians such as Jean Guitton, Thomas Merton, and Fr. Romano Guardini.

Many of the problems associated with the implementation of the conciliar reforms can be traced to communications difficulties endemic to such massive change and the infiltrating influence of secular pressures and distortions. The Church understandably failed to plan and execute the assimilation process as diligently as it did the council's inception and consummation. Through it all, Paul remained faithful to his responsibilities as pope and as a believer, and his simple, unassuming piety endures as an inspiring example.

First Among Equals

One of Paul's trademark expressions, especially prevalent at his weekly audiences in 1972 and 1973, was "whether we like it or not." The pope refused to sugarcoat things or pretend that the challenges of the Gospel were any less difficult for him. Paul led the Church but traveled as one of us.

As we read about what Paul said and did, and most of all lived, we discover possibilities for our own lives and vocations. May the pictures and words of this book be a witness to this humble Christian whose ability to remain joyful and peaceful amid persecution, betrayals, misunderstandings, and rejection serves as a witness and consolation to those of us who undergo similar trials. May we too remain faithful amid this vale of tears to the good news we have received. Pope St. Paul VI, pray for us.

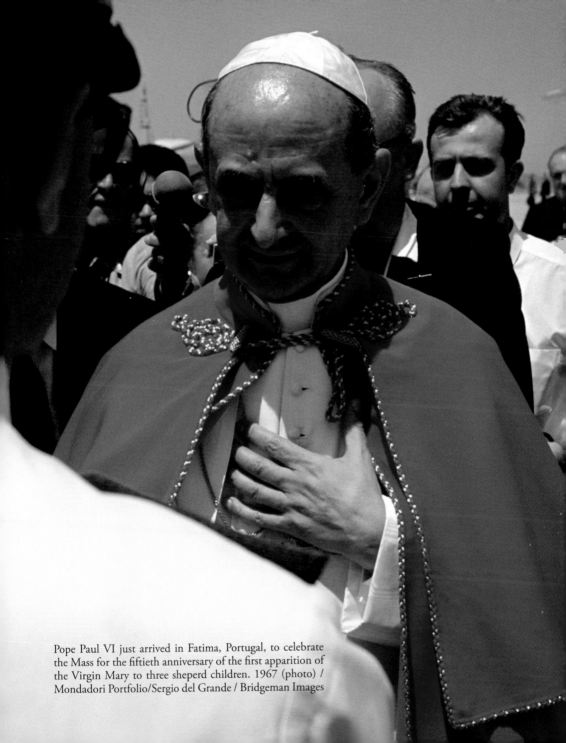

Pope Paul VI just arrived in Fatima, Portugal, to celebrate the Mass for the fiftieth anniversary of the first apparition of the Virgin Mary to three sheperd children. 1967 (photo) / Mondadori Portfolio/Sergio del Grande / Bridgeman Images

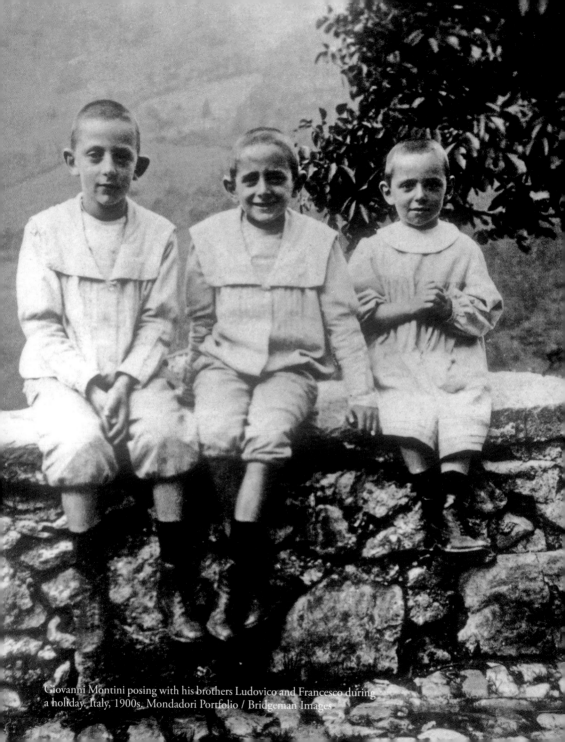

Giovanni Montini posing with his brothers Ludovico and Francesco during a holiday, Italy, 1900s. Mondadori Portfolio / Bridgeman Images

Paul's Life

An Outline of a Priestly Life

Giovanni Battista Enrico Maria Montini was born in Concesio (Lombardy), Italy, on September 26, 1897. His father was Giorgio Montini, an upper class, non-practicing attorney who was editor of the daily newspaper *Il Cittadino di Brescia*. He was a staunch Catholic and knew many in the hierarchy, including Pope St. Pius X. He was well-known for his outspoken support of the Church in the face of anti-clericalism and eventually Fascism. His mother, Giuditta Alghisi Montini, was very active in the community and hailed from the upper class. His older brother, Ludovico (1896–1990), was an attorney and senator, and his younger brother, Francesco (1900–1971), was a doctor.

The future Paul VI was schooled at the Jesuit-staffed Cesare Arici Institute of Brescia. From his earliest days, he was intellectual, articulate, reserved, and self-disciplined. Due to poor health, he had to live at home while studying for the priesthood. His physical frailty would affect him again during his brief stint in the Vatican diplomatic corps in Warsaw, Poland where he was unable to endure the harsh winters. In 1967, he underwent a serious operation after putting it off despite great discomfort

in order to fulfill his papal duties. Paul VI had a gaunt physical presence at 5'8" and came off as austere and distant. However, this belied a warm personality and subtle sense of humor that made him amenable to practical jokes on occasion, especially prior to becoming pope.

ORDINATION AND BEYOND

The future Pope Paul, then Giovanni Montini, was ordained on May 29, 1920. From 1920 to 1923, he spent most of his time at the Pontifical Lombard Seminary and took a variety of courses in history, literature, languages, canon law, and Christian archaeology, the entire course referred to as higher ecclesiastical studies. However, in November 1921, he pursued special studies at the Vatican's Ecclesiastical Academy, where he further honed his diplomatic skills. On December 9, 1922, Montini received his degree in canon law from the Lombardy seminary in Milan. His frail health alluded to above would affect him again when, after having been sent in May 1923 to Warsaw as a minor official at the apostolic nunciature, it caused him to have to return to the Secretariat of State in October of that year. In the summer of 1924, he took courses in French language and literature in Paris, returning to the Secretariat in October where he would remain for the next thirty years until his appointment as archbishop of Milan in 1954.

While in Rome, Paul developed a special rapport with young persons, becoming a mentor to several, including the future prime minister of Italy, Aldo Moro. In December 1923, he was appointed ecclesiastical assistant (chaplain) to Catholic students at the University of Rome, and in October 1925, he was named national ecclesiastical assistant of the Federazione Universitaria Cattolica Italiana (FUCI), where he remained until he resigned in 1933. His openness, intellectualism, and familiarity

with modern philosophy and literature (French in particular) made him particularly appealing to university students.

In October 1924, as mentioned above, Montini was appointed an assistant secretary in the office of the Secretariat of State, and the next year he was promoted to the rank of *minutante,* which was a secretary with access to sensitive diplomatic issues. Among other activities, he researched and then expressed his opposition to the proposed 1929 Lateran (Vatican) concordat with the Fascist government. He caught the attention of Cardinal Eugenio Pacelli, who became secretary of state in 1930 and appointed him to his staff.

Paul was unafraid to voice his opinion even to those in high authority. For example, in 1931, Mussolini—whom Paul, like his father, adamantly opposed—harassed and then suppressed Catholic youth organizations. Paul subsequently helped found the Movimento Laureati Cattolici and continued to work with and encourage university graduates. This ongoing relationship would later lead to tensions with certain members of the curia, including Pacelli himself—later to become pope as Pius XII—when, with Paul's blessing, they adopted political positions in conflict with Vatican preferences. One could argue that in supporting such organizations Paul anticipated Vatican II teachings regarding the distinct role of the laity.

His rise in the Vatican bureaucracy continued when on December 13, 1937, he became substitute secretary of state and secretary of the cipher.

Meanwhile, throughout these years he had, from 1930 to 1937, taught the history of pontifical diplomacy at the Pontifical Institute *Utriusque Iuris* in the St. Apollinare palace.

Paul continued his diplomatic duties on Pacelli's ascent to the papacy in March 1939. Under the now Pius XII, he worked as papal undersecretary of state, and on November 29, 1952, was named pro-secretary for ordinary (internal) affairs. This gave him great insight into the quirks and rubrics of the Vatican bureaucracy and helped prepare him to initiate a reform and reorganization of the curia during his papacy. As with any entrenched bureaucracy, there was substantial resistance, which his successors have likewise encountered.

From 1939 to 1945, Paul oversaw the Vatican Information Office, which helped exchange and track military and civilian prisoners. He was instrumental in the Vatican efforts to give secret asylum to and resettle refugees/displaced persons, especially Jews. Thus, his defense of Pius XII against post-mortem charges of wartime anti-semitism and passivity was based on first-hand knowledge and experience.

On July 19, 1943, Montini accompanied Pius XII on his dangerous visit to the St. Lawrence suburb after a devastating Allied bombing raid. This courageous action drew the attention of the news media and was later widely publicized. On a more personal level, 1943 was a difficult year for Paul, as his parents died within a few months of each other.

We sometimes hear of couples who were so close that the death of one is soon followed by the death of the other. I believe that Paul's great insights into marital love reflect the influence and witness of his loving parents, which he expressed in a pastoral letter on the Christian family while archbishop of Milan as well as in *Humanae Vitae* and in renowned addresses to the Teams of our Lady (May 4, 1970) and the Roman Rota (February 9, 1976, during which he gave an eloquent address on the traditional teaching that valid consent makes an indissoluble marriage). In a charming gesture fraught with symbolism, Paul's mother had her

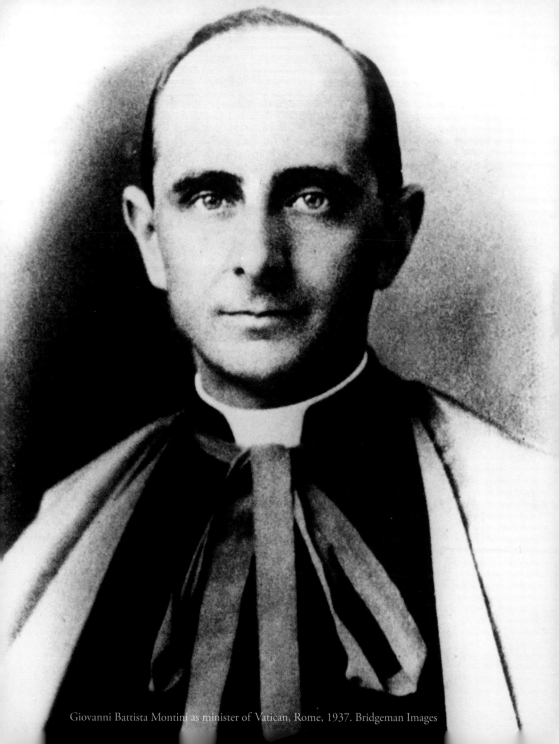

Giovanni Battista Montini as minister of Vatican, Rome, 1937. Bridgeman Images

wedding dress made into the chasuble (liturgical vestment) that Paul wore at his ordination to the priesthood.

In 1951, Paul toured North America, making stops in Washington, DC, Denver, Chicago, Detroit, Pittsburgh, New York, and Quebec.

In 1953, he and the pro secretary of state for extraordinary (foreign) affairs, Monsignor Domenico Tardini, asked to be dispensed from accepting Pius XII's nomination to the cardinalate. As an aside, all throughout his time at the Vatican, Paul was a favorite among the Swiss guards for the polite and respectful way in which he greeted them, and in their informal conversations was discussed as a suitable *papabile*.

ARRIVEDERCI ROMA

On November 1, 1954, Giovanni Montini was appointed archbishop of Milan. He was consecrated archbishop in St. Peter's on December 12, 1954 and was greeted with an enthusiastic welcome on a rainy day in that northern Italian city on January 6, 1955. He became known worldwide for his revitalization of this troubled mega-diocese, which operated in the presence and amongst the influence of a strong Communist faction. He was nicknamed the archbishop of the workers because of his efforts to bridge the gap between the clergy and the working class. He visited factories and delivered addresses that were greeted with warm applause.

Archbishop Montini was an active pastor of souls in Milan, issuing nine pastoral letters while archbishop. They are as follows:

1. Christ Is Everything for Us (February 15, 1955)
2. Observations About the Present Hour (February 19, 1956)
3. The Religious Sense (February 24, 1957)

4. Liturgical Education (February 7, 1958)

5. Our Easter (February 10, 1959)

6. The Christian Family (February 27, 1960))

7. The Moral Sense (February 11, 1961)

8. Thinking About the Council (February 22, 1962)

9. Christian and Temporal Well-Being (February 24, 1963)

One of the interesting persons Paul encountered in Milan and supported amid much controversy was Primo Mazzolari (January 13, 1890–April 12, 1959), better known as don Primo. Serving as a priest in the municipality of Bozzolo in the region of Lombardy, he was a prominent author and activist in the cause of peace and social justice. An advocate of the disenfranchised, he eventually was sanctioned, though his teachings and writings on religious freedom, pluralism, and the necessity for the Church to be an advocate for the poor (a perspective with which one of Paul's fellow archbishops, Cardinal Giacomo Lercaro of Bologna, became widely associated), eventually were reflected in the documents of Vatican II.

As is so often the case with social and religious pioneers, don Primo only began to receive official acceptance toward the end of his life and then after his death. In a decision that brought him an informal rebuke from the curia, Paul invited don Primo to preach in the 1957 archdiocesan mission.

In February 1959, however, Pope John XXIII received don Primo in a private audience and referred to him as "*Tromba dello spirito santo nella Bassa Padana*" (Trumpet of the Holy Spirit in Bassa Padana). In more recent years, Pope Francis gave a speech and prayed at his tomb at St. Peter's Church in Bozzolo.

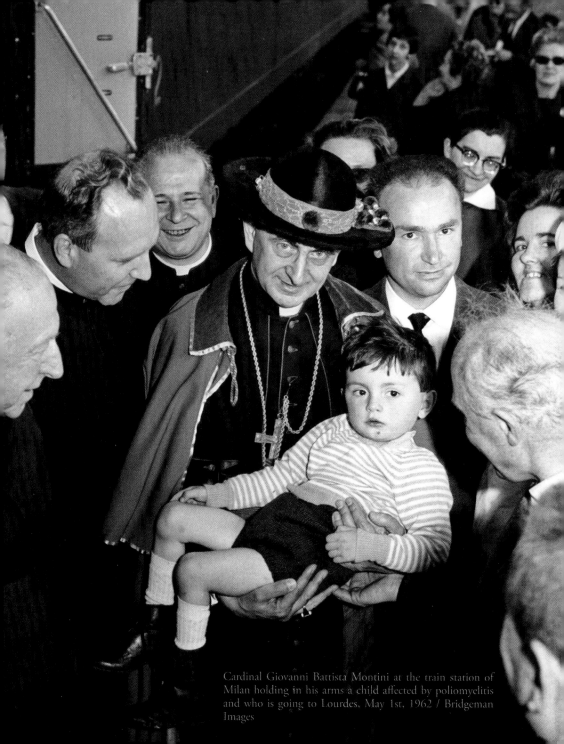

Cardinal Giovanni Battista Montini at the train station of Milan holding in his arms a child affected by poliomyelitis and who is going to Lourdes, May 1st, 1962 / Bridgeman Images

A distinguishing mark of Paul was his humility as indicated by the interesting remark attributed to him when Cardinal Lercaro came to do him homage after his ascension to the papacy. Paul reportedly said, "So that is the way life goes, your Eminence. You should be sitting here rather than me."

The lives of don Primo and Cardinal Lercaro convey an important lesson. Just because we are scrutinized or rebuked by those in religious authority does not automatically put us in the wrong. Inevitably, and this has been verified throughout the Church's history, the most authentic sign of a scrutinized person's integrity is the way they deal with sanctions or official opposition. Is it about them or their cause and principles? Those who become militant and publicly obstinate reflect an egotism incompatible with the positions they purport to represent. Conversely, those who accept their plight in humility speak loudly through their obedience, and typically eventually become exonerated or reinstated.

A classic example of this is Australia's first and sole saint, St. Mary (of the Cross) MacKillop, who was actually excommunicated amid misunderstandings about her pastoral work, but five months later was restored on the orders of the dying bishop who had initiated the excommunication. A number of periti (experts) at the Second Vatican Council had been previously regarded with suspicion, or even sanctioned (e.g., Fr. Karl Rahner) by the Church.

Some reflections on the nature of authority are in order because it is so often misused or unfairly caricatured by agenda-driven critics. People in authority are as human as the rest of us. Carrying a great responsibility, they are not immune to buckling under temptations (especially ambition) and pressure. Who better exemplifies this than the first servant of the servants of God (Pope St. Gregory the Great's nickname for

the pope), St. Peter, whose sincerity and leadership role did not exempt him from a crisis of faith? We would do well to reflect on St. Luke's portrayal of this incident, as well as Jesus's anticipatory exhortation to Peter to "strengthen the brethren" when he had recovered from his fall (cf. Lk 22:31–32). In tandem with St. John's moving account of Jesus's rehabilitation of Peter through his threefold affirmation of his loyalty to Christ (cf. Jn 21:15–19), we see how in the mystery of providence even our weaknesses and failures can be used for the glory of God.

A priest once remarked to me that he believes that when we face God, the failings and disappointments that have caused us the most pain will be the cause of praise from God for our perseverance. Similarly, in *Evangelium Vitae*, St. John Paul II offered a consoling exhortation to women who have had an abortion and ovserved that many such women become great advocates for life.

The common lesson in the above stories was aptly conveyed in a memorable address by Pope Paul VI on April 16, 1969. He counseled us not to become passive screens for the projections of images and propaganda that hit us from every angle in modern life. We need to be discerning, to think for ourselves, and to accept the liberty offered to us by the Holy Spirit. Guided by the Church, Scripture, and conscience, we need to pay attention and respond appropriately to the signs of the times in the context of God's will for us.

In following our conscience, we can encounter opposition even from well-meaning persons in religious circles. Think of Blessed Franz Jägerstätter, whose opposition to military service under Hitler, against counsel from his pastor and many of those around him, eventually lead to his beheading. His words on the eve of his execution remind us of who we ultimately serve and who remains our final judge: "If I must

write . . . with my hands in chains, I find that much better than if my will were in chains. Neither prison nor chains nor sentence of death can rob a man of the Faith and his free will. God gives so much strength that it is possible to bear any suffering. . . . People worry about the obligations of conscience as they concern my wife and children. But I cannot believe that, just because one has a wife and children, a man is free to offend God."

Pope St. Paul VI was not afraid to go against the grain and take on powerful forces. As his closest adviser, he disagreed with Pius XII on occasion. Perhaps his greatest cross, the lack of support he received from some bishops after the issuance of *Humanae Vitae*, is the greatest testimony to the primacy of conscience, which paradoxically opponents of the encyclical often referred to as justification for their dissent. When all the world waited with bated breath for the pope to revise Church teaching on the illicitness of contraception, Paul VI stood strong and, fortified by the Holy Spirit, defended and restated the Church's immemorial teaching on the subject.

Just as his apostolic namesake had received plenty of opposition but persevered in a humble and faithful manner, never resorting to retaliation or bitterness, so did Paul VI as pope. He issued no excommunications during his papacy, despite sustained opposition and offenses. His reluctance to do so was most likely rooted in his commitment to holding the Church together, a desire which extended even to those at the fringes.

In so many ways, Paul VI brought the Church discipline principles articulated in Matthew 18 to life. His peace-making, conciliatory demeanor was reflective of the disposition proposed by Jesus in the magnificent concluding parable of the unforgiving servant (cf. Mt 18:21–35), for which Jesus provided a postscript with an exhortation

that followed his proposal in the Lord's Prayer, so dear to the heart of Paul VI (he often reflected on it and even prayed it in his dying breaths), that unless we forgive others from the heart, we will be subjected to the revocation of our own forgiveness and subsequent damnation. Forgiveness is a central theme of both Jesus and St. Matthew, and in the evangelist's customary intense and sometimes foreboding style, this parable

Jean Guitton / Photo © Louis Monier / Bridgeman Images

brings home its crucial centrality in Christian life.

Perhaps not coincidentally, the subject of the last Lenten curial retreat during Paul's pontificate would be spiritual exercises related to the Gospel of Matthew, given by Fr. Carlo Martini, SJ, who would later follow in Paul's footsteps as archbishop of Milan. Martini writes in his foreword to Pasquale Macchi's memoirs of Paul of the extensive notes taken by the pope during the retreat, despite his debilitating arthritis. The Jesuits were Paul's first and last teachers. His love for the intellectual life prepared him for a ministry that would require an agile and far-thinking mind.

Paul was close to and like-minded intellectually with the only layperson to address the Second Vatican Council, Jean Guitton, a member of the French academy and a philosopher whom Bishop Fulton Sheen described as the leading lay Catholic theologian in the world. Guitton was also a friend of St. John XXIII, which accounts for the aforementioned speaking invitation.

Two books by Guitton are of particular interest with respect to Paul

VI: *Feminine Fulfillment* and *The Pope Speaks: Dialogues of Paul VI with Jean Guitton*. Though born in the nineteenth century, Paul VI had progressive (though not necessarily feminist) attitudes about women, as demonstrated by his being the first pope to proclaim a woman (Teresa of Avila, then Catherine of Siena) as a doctor of the Church (in 1970).

In an address to an Italian women's association, the Centro Italiano Femminile, in December of 1976, he postulated that women's horizons and potentialities had, as yet, not been fully realized within the Church: "Within Christianity, more than in any other religion, and since its very beginning, women have had a special dignity, of which the New Testament shows us many important aspects . . . ; it is evident that women are meant to form part of the living and working structure of Christianity in so prominent a manner that perhaps not all their potentialities have yet been made clear." Guitton's insights into femininity reflect a similar keen insight into human nature and the distinctiveness of the sexes.

His book of dialogues with Paul VI is an imaginative reconstruction of his many conversations with his friend, and an application to contemporary issues, for which he received Paul's succinct stamp of approval: "You have written well of us." It was one of the most widely read books about Paul VI during his papacy.

I cannot imagine a more fitting conclusion to our overview of Paul's life than the synopsis offered by his secretary, Monsignor Macchi. He was kind enough to send a written letter of encouragement to me while I was writing my first book on Paul VI, and insightfully suggested that I incorporate my own experiences and perspectives in the book. He also sent me a copy of the Italian edition of his memoirs of Paul VI.

In the English translation of that volume is found Macchi's poignant assessment of Paul VI:

He felt himself to be no more than a servant of all those whom he met and especially towards those closest to him. A growing charity developed from his faith. Often he waited for me in the small hours of the night, when I returned home from some journey.

Paul VI's entire life was a hymn to hope, in the certainty of the love of God who reveals himself to us as Father, and of his presence as Savior of the world. God's love becomes incarnate in the one who gives himself to him without reserve.

Paul VI, Pope of joy in the sufferings of everyday life, is our guide in the journey of the light of God, and in the following of Christ who has come to dwell among us.

Paul VI is the man of hope, of love and of trust, of faith, of charity and of conversion. He uncovers to the world his great dream: *a civilization of love.*

As one who so closely hewed to the guidance of the Holy Spirit, it was perhaps most fitting that Paul VI gave cautious validation to the Charismatic movement which began in Catholic circles at Duquesne University in Pittsburgh in 1967. He gave a moving address on the Holy Spirit at an international conference of charismatics that convened in Rome in 1975. Fr. Edward O'Connor, CSC, published a very good compendium of Paul's teachings on the Holy Spirit entitled: *Pope Paul VI and the Spirit.*

And so, recalling the words and witness of Paul VI, may we too allow the Spirit to become the guiding force in our life.

(*opposite*) Pope Paul VI is helped down a helicopter by his personal physician Prof. Mario Fontana (L) and his personal secretary Msgr. Pasquale Macchi on his arrival at his summer residence at Castel Gandolfo in 1975. (Ap Photo)

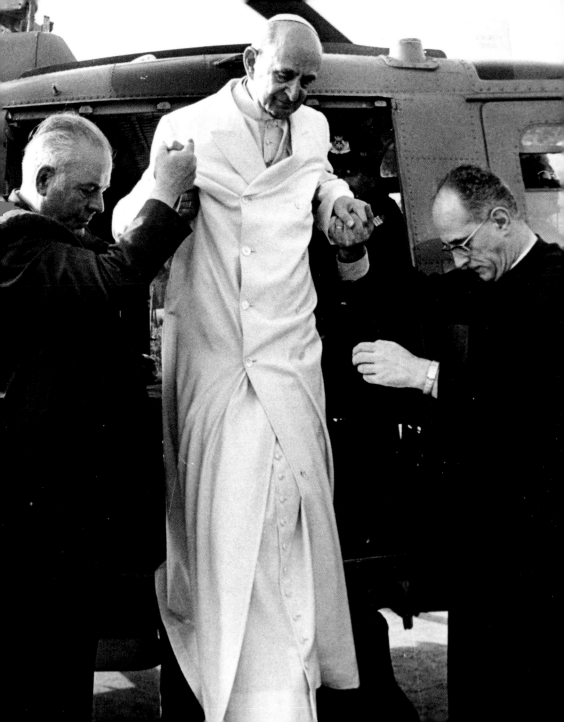

Presented in interludes here and throughout the book is Paul's lamentably little-known Credo of the People of God. A dynamic restatement of the Faith, reported to have been penned by Jacques Maritain, all the faithful would do well to read and meditate on it, especially now that the man who promulgated it has been elevated to the altars. This first part, his introduction, stands as a testament to Pope St. Paul's intentions.—Ed.

Apostolic Letter
In the Form of *Motu Proprio*

Solemni Hac Liturgia (Credo of the People of God)

Of the Supreme Pontiff Paul VI
June 30, 1968

1. With this solemn liturgy we end the celebration of the nineteenth centenary of the martyrdom of the holy apostles Peter and Paul, and thus close the Year of Faith. We dedicated it to the commemoration of the holy apostles in order that we might give witness to our steadfast will to be faithful to the deposit of the faith [Cf. 1 Tim. 6:20] which they transmitted to us, and that we might strengthen our desire to live by it in the historical circumstances in which the Church finds herself in her pilgrimage in the midst of the world.

2. We feel it our duty to give public thanks to all who responded to our invitation by bestowing on the Year of Faith a splendid completeness through the deepening of their personal adhesion to the word of God, through the renewal in various communities of the profession of faith, and through the

testimony of a Christian life. To our brothers in the episcopate especially, and to all the faithful of the holy Catholic Church, we express our appreciation and we grant our blessing.

A Mandate

3. Likewise, we deem that we must fulfill the mandate entrusted by Christ to Peter, whose successor we are, the last in merit; namely, to confirm our brothers in the faith [Cf. Lk. 22:32]. With the awareness, certainly, of our human weakness, yet with all the strength impressed on our spirit by such a command, we shall accordingly make a profession of faith, pronounce a creed which, without being strictly speaking a dogmatic definition, repeats in substance, with some developments called for by the spiritual condition of our time, the creed of Nicea, the creed of the immortal tradition of the holy Church of God.

4. In making this profession, we are aware of the disquiet which agitates certain modern quarters with regard to the faith. They do not escape the influence of a world being profoundly changed, in which so many certainties are being disputed or discussed. We see even Catholics allowing themselves to be seized by a kind of passion for change and novelty. The Church, most assuredly, has always the duty to carry on the effort to study more deeply and to present, in a manner ever better adapted to successive generations, the unfathomable mysteries of God, rich for all in fruits of salvation. But at the same time the greatest care must be taken, while fulfilling the indispensable duty of research, to do no injury to the teachings of Christian doctrine. For that would be to give rise, as is unfortunately seen in these days, to disturbance and perplexity in many faithful souls.

Paul's Will

Paul VI's will, completed over a period of years, stands as a testament to his unquenchable love of Christ, life, and the Church. It can inspire us to think about our own testament and life mission and perspective. How might we respond to this inspiring provocation from Paul VI that in some ways is the highlight of his will? "Why have I not studied, explored, admired sufficiently this place in which life unfolds? What unpardonable distraction, what reprehensible superficiality! However, even at the last we should recognize that this world, qui per Ipsum factus est, which was made through him, is amazing." That passage, in turn, leads to the climax of his homage, once again a reference to the Lord's Prayer: "This world's scene is the design, still today incomprehensible for the most part, of a Creator God, who calls himself our father in heaven. Thank you, O God, thanksgiving and glory to you, Father" (Paul VI's Testament, June 30, 1965, with additional notations on September 16, 1972 and July 14, 1973).

Fr. Yves Congar provided a fitting commentary on Paul's death and final viewing:

> Paul died with the words "Our Father who are in heaven" on his lips. It was the death he had always prayed for. "What is the greatest misfortune here below?" he had asked, and answered, "to be unable to say 'Our Father'" (April 16, 1965). "What is the Church doing in this world?" he asked on another occasion, and replied, "Making it possible for us to say 'Our Father'" (March 23, 1966).
>
> The coffin was surmounted, not by the tiara that he had given away, not even by a mitre or a stole, but by the open book of the Gospels, its pages rifled by the light breeze. Like a breath of the Holy Spirit.

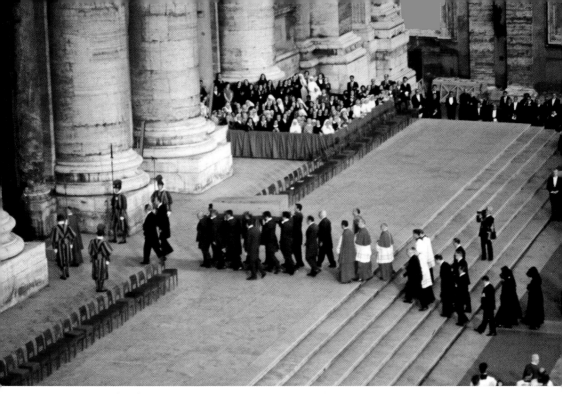

The coffin of Pope Paul VI entering Saint Peter's Basilica, Vatican City, Vatican City State / Mondadori Portfolio / Bridgeman Images

In his will, Paul dictated:

> As regards my funeral: let it be simple and animated by religious piety (I do not wish to have the catafalque, as is the custom for the funerals of Popes; instead let things be carried out in a humble and becoming manner).
>
> As regards my tomb: I would like to be buried in the earth with a simple stone to indicate the place and invite a prayer of Christian piety. No monument for me.

No monument, perhaps, but a richly deserved sainthood.

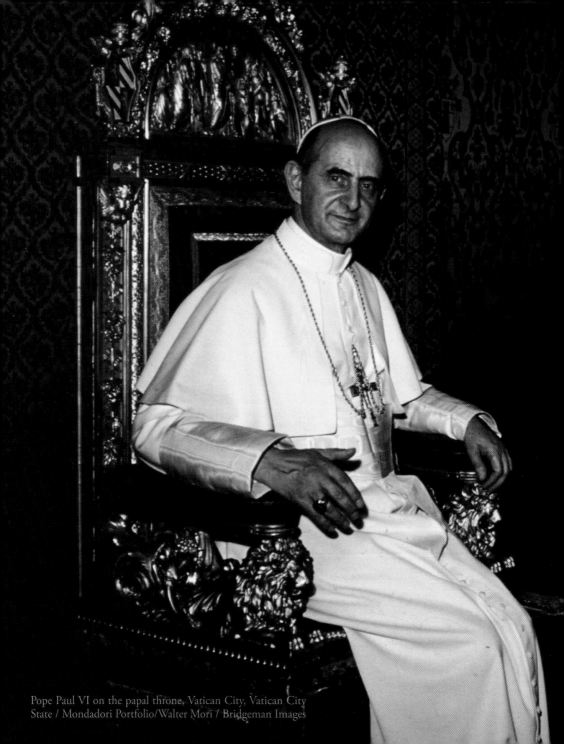

Pope Paul VI on the papal throne, Vatican City, Vatican City
State / Mondadori Portfolio/Walter Mori / Bridgeman Images

Paul's Pontificate

Pope St. Paul VI initiated and oversaw more changes than any pope in modern history. In many ways, he could arguably be considered the most influential Catholic of the twentieth century—for good in the minds of some and for ill in the minds of others—and perhaps the most assailed as well. Facing problems that had been simmering during Pius XII's pontificate and had ignited during John XXIII's, he was bound to alienate and disappoint many.

In his Angelus address on August 3, 2008, in recognition of the upcoming thirtieth anniversary of Paul VI's death, Pope Benedict XVI observed:

> Divine Providence summoned Giovanni Battista Montini from the See of Milan to that of Rome during the most sensitive moment of the Council—when there was a risk that Blessed John XXIII's intuition might not materialize. How can we fail to thank the Lord for his fruitful and courageous pastoral action?
>
> As our gaze on the past grows gradually broader and more aware, Paul VI's merit in presiding over the Council Sessions,

in bringing it successfully to conclusion and in governing the eventful post-conciliar period appears ever greater, I should say almost superhuman. We can truly say, with the Apostle Paul, that the grace of God in him "was not in vain" (cf. 1 Cor 15: 10): it made the most of his outstanding gifts of intelligence and passionate love for the Church and for humankind. As we thank God for the gift of this great Pope, let us commit ourselves to treasure his teachings.

In this section of the book, we will turn our attention to Paul's teachings, which, as Benedict observed, remain relevant and continue to influence his successors.

When assessing Paul VI's pontificate, we have to both begin and end with his facilitation and implementation of Vatican II. He inherited a council he would not have called—and which many observers intuited John XXIII could not have successfully concluded—because his years in the curia had alerted him to the intransigence of the Vatican bureaucracy and the resistance that a major initiative of this sort would evoke. Paul was a risk-taker, but not in a grandiose way, and it is doubtful he would have undertaken such an initiative, for on the surface, the Church did not seem in crisis.

As the council wore on, and in hindsight a half century later, the crisis within the Church may not have been obvious, but there were serious lingering problems that needed to be addressed for the Church to respond appropriately to the times.

At the time of the council, in this author's considered opinion, the Church was still in a defensive posture with respect to three great historical challenges: the Reformation, the Enlightenment, and the Modernist movement, which, in a sense, grew out of the Enlightenment. During Pius

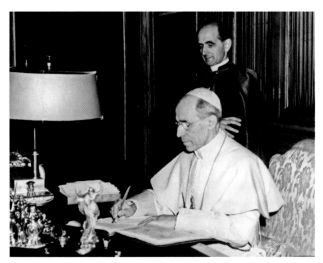

Cardinal Giovanni Battista Montini (future Pope Paul VI) minister of Vatican here in the office of Pope Pius XII (Eugenio Pacelli, Pope in 1939-1958) in Rome, 1952

XII's and John XXIII's pontificates, steps had been taken to move beyond these more defensive or reactionary stances, but it took the force of the ecumenical council to lay an enduring foundation in the form of those documents that articulated the Church's evolving self-understanding and mission in the modern world.

As part of this developmental process, abuses and exaggerations (overcompensations) occurred, causing some to bemoan the council and doubt its efficacy and seek a return to seemingly simpler times. A restorationist ideology developed, which, though it sought to conserve much that was good, could, perhaps justly, be accused of failing to recognize that while essential elements of Tradition must be safeguarded, that Tradition itself is not static and must be allowed to deepen and evolve in its expression. Paul's *Credo of the People of the God* was an apt example of such evolution.

Await the Word

5. It is important in this respect to recall that, beyond scientifically verified phenomena, the intellect which God has given us reaches that which is, and not merely the subjective expression of the structures and development of consciousness; and, on the other hand, that the task of interpretation—of hermeneutics—is to try to understand and extricate, while respecting the word expressed, the sense conveyed by a text, and not to recreate, in some fashion, this sense in accordance with arbitrary hypotheses.

6. But above all, we place our unshakable confidence in the Holy Spirit, the soul of the Church, and in theological faith upon which rests the life of the Mystical Body. We know that souls await the word of the Vicar of Christ, and we respond to that expectation with the instructions which we regularly give. But today we are given an opportunity to make a more solemn utterance.

7. On this day which is chosen to close the Year of Faith, on this feast of the blessed apostles Peter and Paul, we have wished to offer to the living God the homage of a profession of faith. And as once at Caesarea Philippi the apostle Peter spoke on behalf of the twelve to make a true confession, beyond human opinions, of Christ as Son of the living God, so today his humble successor, pastor of the Universal Church, raises his voice to give, on behalf of all the People of God, a firm witness to the divine Truth entrusted to the Church to be announced to all nations.

 We have wished our profession of faith to be to a high degree complete and explicit, in order that it may respond in a fitting way to the need of light felt by so many faithful souls, and by all those in the world, to whatever spiritual family they belong, who are in search of the Truth.

To the glory of God most holy and of our Lord Jesus Christ, trusting in the aid of the Blessed Virgin Mary and of the holy apostles Peter and Paul, for the profit and edification of the Church, in the name of all the pastors and all the faithful, we now pronounce this profession of faith, in full spiritual communion with you all, beloved brothers and sons.

Profession of Faith

8. We believe in one only God, Father, Son and Holy Spirit, creator of things visible such as this world in which our transient life passes, of things invisible such as the pure spirits which are also called angels[Cf. Dz.-Sch. 3002], and creator in each man of his spiritual and immortal soul.

9. We believe that this only God is absolutely one in His infinitely holy essence as also in all His perfections, in His omnipotence, His infinite knowledge, His providence, His will and His love. He is He who is, as He revealed to Moses [Cf. Ex. 3:14]; and He is love, as the apostle John teaches us [Cf. 1 Jn. 4:8]: so that these two names, being and love, express ineffably the same divine reality of Him who has wished to make Himself known to us, and who, "dwelling in light inaccessible" [Cf. 1 Tim. 6:16], is in Himself above every name, above every thing and above every created intellect. God alone can give us right and full knowledge of this reality by revealing Himself as Father, Son and Holy Spirit, in whose eternal life we are by grace called to share, here below in the obscurity of faith and after death in eternal light. The mutual bonds which eternally constitute the Three Persons, who are each one and the same divine being, are the blessed inmost life of God thrice holy, infinitely beyond all that we can conceive in human measure [Cf. Dz.-Sch. 804]. We give thanks, however, to the divine goodness that very many believers can testify with us before men to the unity of God, even though they know not the mystery of the most holy Trinity.

But the history of the overreach of some reformers and the reaction of some traditionalists is beyond the scope of this book. Suffice to say that, through the graces of providence, the Church has been blessed with pontiffs who have affirmed and supported the council, while safeguarding it through corrective, refining, and in some cases disciplinary measures. As with the Bible, it has often been the case that agenda-driven misinterpretations and distortions of the conciliar texts have caused the problems, rather than the texts themselves.

DIPLOMATIC DISCERNMENT AND PRUDENCE

In order to reach a consensus in approving the documents, compromises had to be made. Not all issues were immediately resolvable. However, a diplomat like Paul VI was well-equipped to discern the trade-offs that would be necessary to preserve Church unity.

Because he was a complex thinker who was sensitive to a multitude of nuances and contingencies and was well aware of the personalities and agendas involved, Paul was concerned about the forces that would be unleashed by an ecumenical council and would likely have approached the *aggiornamento*[1] challenge differently.

However, aided by the encouragement of his confessor and spiritual guide, Fr. Giulio Bevilacqua, he quickly became an advocate of the council and was instrumental in its preparations.

The cardinals who congregated at the conclave to select "good Pope John's" successor knew that Paul VI was a supporter of the council, and

[1] An Italian word meaning roughly "bringing up to date." It is a key phrase associated with the Second Vatican Council as well as with the pontificates of John XXIII and Paul VI.

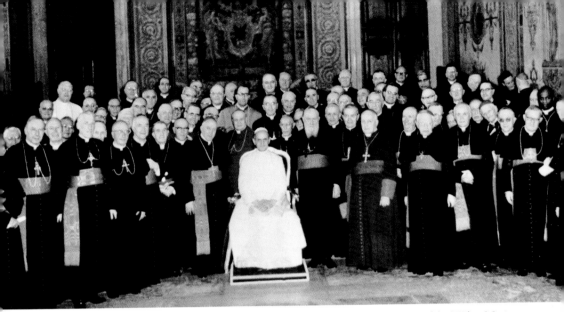

Pope Paul VI with cardinals of Conclave, 1963 (b/w photo) / Mondadori Portfolio/Walter Mori / Bridgeman Images

this accounted for much of both the support and opposition that he received in the conclave.

The council was between sessions at the time of St. John XXIII's death, and his successor would not be bound to continue it, so upon his election, Paul VI acted quickly to confirm his support for its resumption.

As Benedict XVI pointed out, Paul VI had the gifts and disposition to successfully bring the council to its conclusion. He considered the various sides to the issues, along with their respective adherents and opponents, and sought to maintain them in a healthy tension. He steered the Church along a middle path, as is her tradition, for which he was vilified by some and appreciated by others.

Anticipating the bishops' synods that he would inaugurate, Paul let the conciliar participants have their say and intervened with the greatest discretion. His greatest achievement not only during the council but in his entire pontificate was holding the Church together.

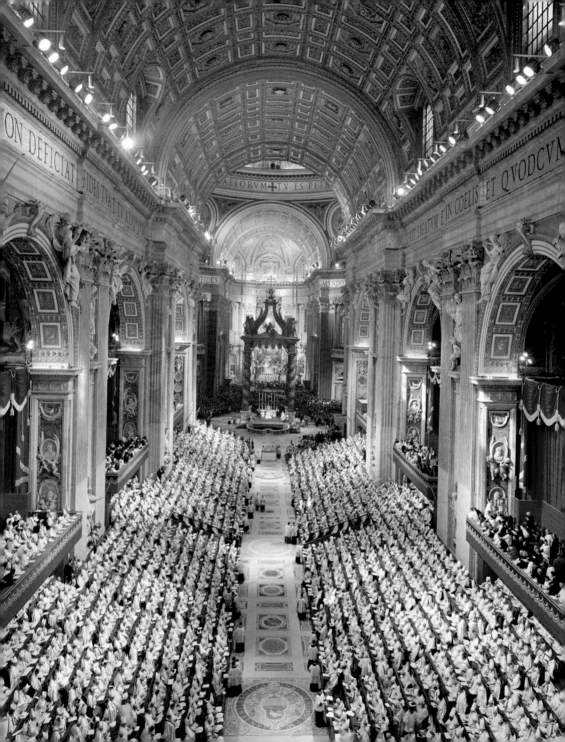

As a diplomat, Paul VI was skilled at conflict resolution and consensus building, and was able to wade through the various currents and somehow get them flowing in the same direction, without suppressing or artificially fusing them.

Experienced observers of church affairs have recognized the magnitude of Paul's conflict resolution efforts, particularly given the diversity of participants in the council and the complexities and sensibilities implicit in the implementation efforts afterward. In the process, he received considerable criticism from many quarters. Many of the issues were not amenable to easy resolution, and compromises and conciliatory allowances had to be made.

Mary's Place

This diplomatic skill was needed during the debate in the third session of the council over whether to have a separate document devoted to Mary, or to include a chapter on her at the conclusion of the Dogmatic Constitution on the Church (*Lumen Gentium*)—which in itself is a positive testimony. The bishops from the southern hemisphere generally preferred the former, while many from Europe preferred the latter, which view eventually prevailed.

Partly as a gesture to the disappointed bishops, Paul accorded Mary the title "Mother of the Church" on the last day of the third session of the council. Accounts vary as to the reception of Paul's gesture, but he did not do this as a mere publicity stunt, nor a patronizing appeasement. He published two encyclicals on Mary, and one apostolic exhortation, *Marialis Cultus,* which is recognized as an insightful and balanced treatise on Mary and was notable for its synthesis of biblical teaching on the Mother of God.

(*opposite*) Second Vatican Council Convened in 1963 (photo) / St. Peter's, Vatican City / Bridgeman Images

Paul's proclamation of Mary's universal maternity stands as an example of his prudent and prophetic gestures that were not fully appreciated at the time. Because there is biblical justification for this title (cf. Jn 19:25–27), its negative effects on the ecumenical movement were negligible, and it simply made official an aspect of Mary's role within the Church that had been recognized for centuries. On March 3, 2018, Pope Francis affirmed Paul's proclamation by designating the first Monday after Pentecost as a feast commemorating "the Blessed Virgin Mary, Mother of the Church."

This liturgical placement recognizes her prayerful presence within the early Church (Acts 1:14). Mary kept abreast of and reflected upon key events in the life and ministry of Jesus and was present at the foot of the Cross. She and her silent partner, St. Joseph, model what it means to receive the word of God reverently and prayerfully put it into practice (cf. Lk 11:28).

More widely appreciated was Paul's outreach to the Eastern Orthodox, culminating in Rome and Constantinople's December 7, 1965 mutual withdrawing of excommunications dating to 1054. His historic embrace of the Patriarch of Constantinople, Athenagoras I, on January 6, 1964, became the first of several initiatives undertaken by Paul and his successors to begin healing the millennium-long schism. Paul's last major encounter with the Orthodox was also the scene of one of Paul's most poignant and provocative gestures: his kissing of the feet on December 16, 1975 of the envoy of Patriarch Demetrios I, Metropolitan Meliton of Chalcedon. When the Metropolitan tried to reciprocate, Paul prevented him, and allowed him to kiss his ring instead. Thus was the dramatic scene of the foot-washing at the Last Supper (cf. Jn 13) reenacted amid a broken Christendom taking steps toward reunification.

PAUL'S TRAVELS

Pope Paul's pilgrimages were among the most unprecedented and publicized aspects of his papacy. He broke out of the "prisoner of the Vatican" constraints experienced by his predecessors and undertook a number of historic visits. His pilgrimages had tremendous impact on the countries and regions involved, but three that occurred during the council stand out for their visibility and broad implications.

The Holy Land

The first was his visit to the Holy Land in January 1964. Of course, his reconciliation with Patriarch Athenagoras I had universal implications, along with his return to the Christian homeland that no pope had visited since apostolic times. An address that he gave at the Basilica of the Annunciation in Nazareth on January 5 was notable for its humanization and contemporization of the Holy Family, which is particularly relevant given the Church's recent focus on the family.

During this homily, Paul showed how Jesus, Mary, and Joseph modeled true family values and set a standard for members of both sexes. He then went on to provide a contemporary adaptation of the Beatitudes:

> Blessed are we, if, having acquired the meekness of the strong, we learn to renounce the deadly power of hate and vengeance. . . .
>
> Blessed are we, if we do not make egoism the guiding criterion of our life, nor pleasure its purpose, but learn rather to discover in sobriety our strength, in pain a source of redemption, in sacrifice the very summit of greatness.
>
> Blessed are we, if we prefer to be the oppressed rather than the oppressors, and constantly hunger for the progress of justice.

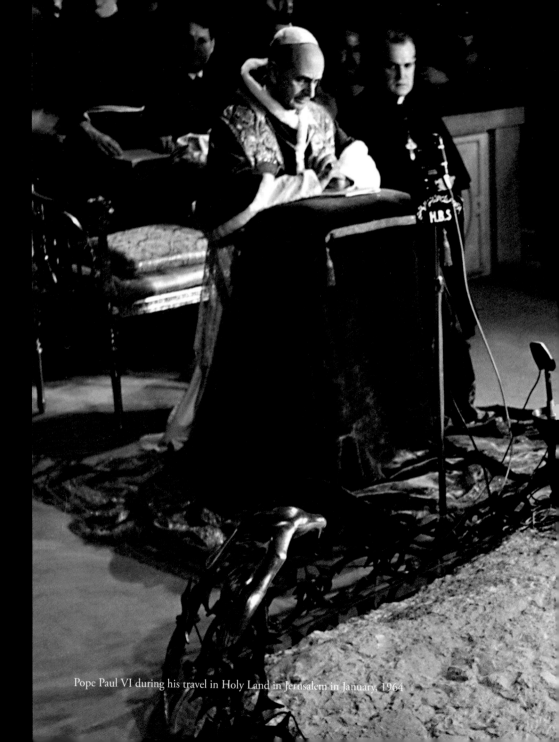

Pope Paul VI during his travel in Holy Land in Jerusalem in January, 1964

Blessed are we, if for the Kingdom of God in time and
beyond time we learn to pardon and to persevere, to work and
to serve, to suffer and to love.

We shall never be deceived.

Each of these adaptations of the Beatitudes merits reflection and discussion, and most of all, application. Paul did the Church and the world a great service by highlighting how the lives of the Holy Family, each member in their own particular way, reflected the spirit of the Beatitudes, and thus we are called to the same. His last line, enigmatic at first, bears comment.

The devil is the deceiver par excellence, and the diabolical instigator of human misery. Conversely, Jesus is the prophet and dispenser of heavenly happiness, of which we get a foretaste on earth by embracing divine values which are also human. The pope is saying that if we internalize and live out these values, we will not be misled, and we will proceed on the path of truth.

India

Paul's second international pilgrimage was likewise eventful. In December 1964, in response to the invitation of Cardinal Gracias, archbishop of Mumbai (Bombay), Pope Paul VI visited Mumbai to attend the Eucharistic Congress. People were uncertain of the reception the pope would receive given the fact that Catholics were a substantial minority in India. Surprisingly, he was received with fervent enthusiasm. Though not a state visit, India's political dignitaries greeted him, and he immersed himself in the culture. Because of India's vast poverty, two events merit commentary.

The first was his visit to an orphanage in which he dispensed com-

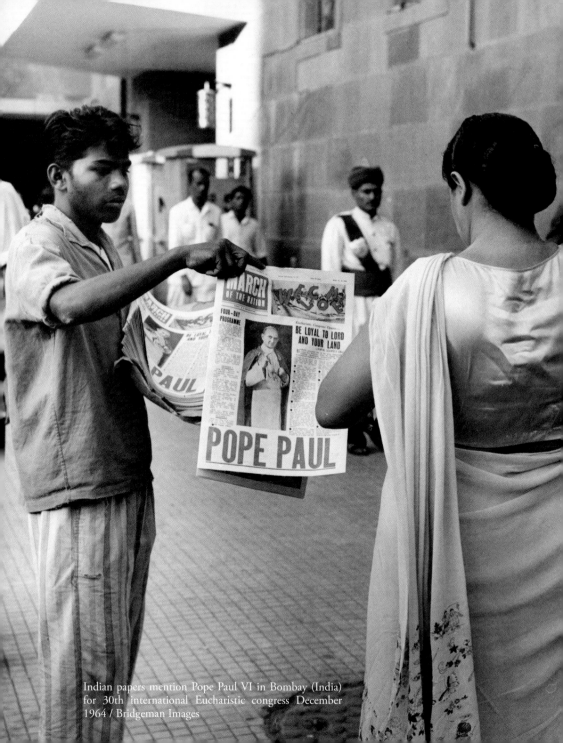

Indian papers mention Pope Paul VI in Bombay (India) for 30th international Eucharistic congress December 1964 / Bridgeman Images

munion on his knees to malnourished children. He gave the orphanage a gift of $10,000 and his vestments as a memento. He took time to directly encounter the impoverished and disadvantaged of India, culminating in his trek to the destitute northern quadrant of the city that housed many of the city's textile workers.

To the dismay of his security entourage, he got out of his limousine and walked through the filthy streets, breaking down in tears at the abject poverty. I remember my mother telling me about Paul's crying episode in order to sensitize me to the need for both thankfulness and charity. Compassionate, pastoral interactions such as these inevitably endure longer in memory than formal ceremonies and addresses.

New York City

Paul's third international pastoral visit was much briefer yet more widely publicized. During the closing session of the council, on October 2, 1965, Paul VI conducted a one-day whirlwind visit to New York City that spawned a cottage industry of commemorative books, records, and mementos. For the first time, a pope had visited the New World.

While his visit was in response to U.N. General Secretary U Thant's invitation to address a general assembly of the United Nations, it also included other significant events, culminating in the Mass for peace at Yankee Stadium, which over ninety thousand people attended.

However, it was his historic speech at the United Nations for which this trip will be primarily remembered, and his poignant plea, "Never again war. Never again war." Paul VI was truly a pilgrim of peace and proved to be its staunch advocate throughout his pontificate both within the Church and without. He maintained unity amid growing diversity and dissension within the Church and sought to promote

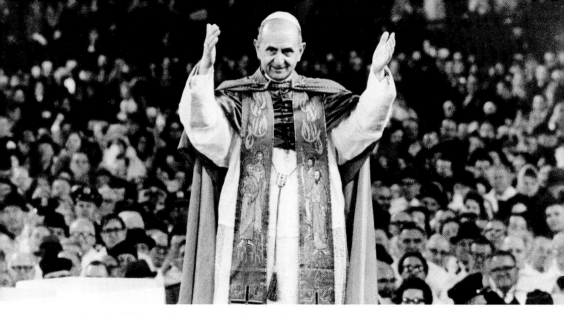

Pope Paul VI raises his hands to give his final blessing to more than 90,000 persons who jammed New York's Yankee Stadium in the Bronx, Oct 4, 1965. That night the Mass ended the Pope's daylong visit in his quest for world peace. (AP Photo)

political unity and peace as well. He participated in negotiations to end the war in Vietnam and established the annual world day of peace on January 1, 1968.

Paul VI tirelessly worked for peace and was truly a peacemaker (cf. Mt 5:9). In this he followed in the footsteps of Pius XII and John XXIII and set an example for his successors.

Mass Appeal in New York City

The Mass for peace at Yankee Stadium stands in contrast to another mass gathering that occurred in New York City on August 15 at Shea Stadium. There the Beatles performed before the largest concert crowd up to that time, fifty-five thousand. The hype and hopes stand in stark contrast.

The pope came offering an enduring happiness based on timeless principles and eternal values and beliefs. The Beatles music is, to many

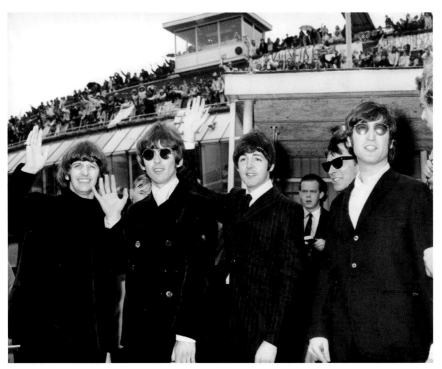

The Beatles on August 11, 1966 acclaimed by fans at airport leaving London for a tour in USA / Bridgeman Images

of their fans, timeless, but the cult around them was alarming and at times disturbing. The Beatles themselves recognized this and ceased giving concerts a year after their Shea experience.

The ephemeral hysteria of some attendees at the concert can be contrasted with the spiritual and communal fervor of participants in the Mass for peace who received a food that brings eternal life. Pope Paul VI enjoyed classical music and approved of cultural and aesthetic pursuits, but in the context of reverence for the source of all human gifts. Music, like art and other cultural phenomena, can bring people together, but

only when it is imbued and guided by proper values.

In 1966, a furor arose in the United States over a remark by John Lennon that the Beatles were bigger than Jesus Christ. He elaborated on this in terms of what he perceived as a decline in religious sensibilities during an interview with a friend and reporter, Maureen Cleave, that was originally published in the *London Evening Standard* on March 4, 1966 and was subsequently picked up by the US teen magazine *Datebook*. This caused little stir in England but created a furor in America, especially in the Bible Belt, on the eve of their US tour. One southern disc jockey even promoted the burning rather than the playing of Beatles' records. In the face of intense media pressure, Lennon apologized for the remark in a Chicago press conference on August 11, 1966.

Interestingly, the Vatican newspaper, *L'Osservatore Romano*, was relatively muted in its response, observing that "some subjects must not be dealt with profanely, even in the world of beatniks." While acknowledging the inappropriateness and offensiveness of the comment, one might also ponder the likelihood that many more Catholics listened to Beatles music religiously and bought their records than read the pope's February 17, 1966, Apostolic Constitution on Abstinence and Fasting ("*Paenitemini*").

Assassination Attempt

Paul's travels were not without their dangers, however. Though it has been forgotten by many and overshadowed by the attempt on John Paul II's life, Paul VI himself was the object of an assassination attempt at the Manila airport in 1970. Coincidentally, it was there that the Beatles were also physically assaulted by the pressing crowds and the people supposed to protect them, the security detail. They had unknowingly insulted the Filipino first lady, Imelda Marcos, by not responding to an invitation (of which they were unaware) for a visit to the presidential place. They, like Paul, were lucky to get out with their lives.

Paul's close call was a bit different. An individual known as "the mad painter," Benjamin Mendoza y Amor, clad in priest garb attempted to stab Paul with a foot-long knife, only to be foiled by Monsignor Macchi, Bishop Galvin of Singapore, and Fr. Paul Marcinkus, who would subsequently become a prominent and controversial player in the Vatican finances.

Later named an archbishop, the hulking Marcinkus, nicknamed "the gorilla," was something of a defender of the pope and an unofficial member of his security team. In 1969, he told secret service agents that they were not welcome to be present during Paul VI's meeting with President Nixon, telling them, "I'll give you 60 seconds to get out of here or you can explain to the president why the pope could not see him today." Apparently, he made that "perfectly clear," to use the president's famous phrase, and the meeting took place. In 1982, he thwarted an assassination attempt against Pope John Paul II in Fatima, Portugal when a deranged, or simply disgruntled, priest attacked the pope with a bayonet.

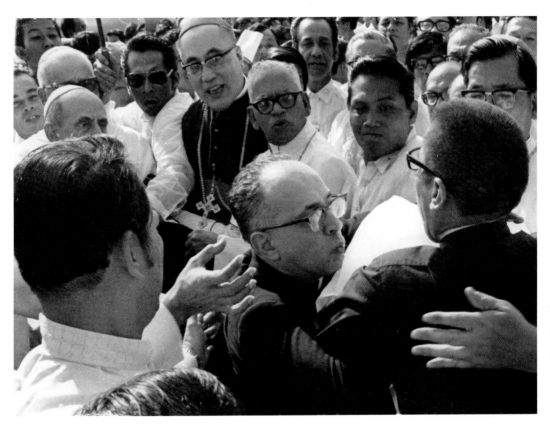

Msgr. Pasquale Macchi (C), private secretary to Pope Paul VI, pushes away a crew-cut, cassock-clad man (R) trying to attack the Pope with a knife at the airport in Manila, Philippines, shortly after the Pope's arrival on November 27, 1970. Police identified the would-be assassin as Benjamin Mendoza Y Amor, 35, of La Paz, Bolivia. Mendoza is an artist who has been living in the Philippines. Pope Paul VI is partially concealed at left, while the Philippines President, Ferdinand Marcos, is at the extreme left. (UPI Photo/Files)

The Father

10. We believe then in the Father who eternally begets the Son; in the Son, the Word of God, who is eternally begotten; in the Holy Spirit, the uncreated Person who proceeds from the Father and the Son as their eternal love. Thus in the Three Divine Persons, coaeternae sibi et coaequales [Cf. Dz.-Sch. 75], the life and beatitude of God perfectly one superabound and are consummated in the supreme excellence and glory proper to uncreated being, and always "there should be venerated unity in the Trinity and Trinity in the unity" [Cf. ibid].

The Son

11. We believe in our Lord Jesus Christ, who is the Son of God. He is the Eternal Word, born of the Father before time began, and one in substance with the Father, homoousios to Patri [Cf. Dz.-Sch. 150], and through Him all things were made. He was incarnate of the Virgin Mary by the power of the Holy Spirit, and was made man: equal therefore to the Father according to His divinity, and inferior to the Father according to His humanity [Cf. Dz.-Sch. 76]; and Himself one, not by some impossible confusion of His natures, but by the unity of His person [Cf. ibid].

12. He dwelt among us, full of grace and truth. He proclaimed and established the Kingdom of God and made us know in Himself the Father. He gave us His new commandment to love one another as He loved us. He taught us the way of the beatitudes of the Gospel: poverty in spirit, meekness, suffering borne with patience, thirst after justice, mercy, purity of heart, will for peace, persecution suffered for justice sake. Under Pontius Pilate He suffered—the Lamb of God bearing on Himself the sins of the world, and He died for us on the cross, saving us by His redeeming blood. He was buried, and, of His own power, rose on the third day, raising us by His resurrection to that sharing in the divine life which is the life of grace. He ascended to heaven, and He will come again, this time in glory, to judge

the living and the dead: each according to his merits—those who have responded to the love and piety of God going to eternal life, those who have refused them to the end going to the fire that is not extinguished.

And His Kingdom will have no end.

The Holy Spirit

13. We believe in the Holy Spirit, who is Lord and Giver of life, who is adored and glorified together with the Father and the Son. He spoke to us by the prophets; He was sent by Christ after His resurrection and His ascension to the Father; He illuminates, vivifies, protects and guides the Church; He purifies the Church's members if they do not shun His grace. His action, which penetrates to the inmost of the soul, enables man to respond to the call of Jesus: Be perfect as your Heavenly Father is perfect (Mt. 5:48).

14. We believe that Mary is the Mother, who remained ever a Virgin, of the Incarnate Word, our God and Savior Jesus Christ [Cf. Dz.-Sch. 251-252], and that by reason of this singular election, she was, in consideration of the merits of her Son, redeemed in a more eminent manner [Cf. Lumen Gentium, 53], preserved from all stain of original sin [Cf. Dz.-Sch. 2803] and filled with the gift of grace more than all other creatures [Cf. Lumen Gentium, 53].

15. Joined by a close and indissoluble bond to the Mysteries of the Incarnation and Redemption [Cf. Lumen Gentium, 53, 58, 61], the Blessed Virgin, the Immaculate, was at the end of her earthly life raised body and soul to heavenly glory [Cf. Dz.-Sch. 3903] and likened to her risen Son in anticipation of the future lot of all the just; and we believe that the Blessed Mother of God, the New Eve, Mother of the Church [Cf. Lumen Gentium, 53, 56, 61, 63; cf. Paul VI, Alloc. for the Closing of the Third Session of the Second Vatican Council: *A.A.S.*LVI [1964] 1016; cf. Exhort. Apost. Signum Magnum, Introd.], continues in heaven her maternal role with regard to Christ's members, cooperating with the birth and growth of divine life in the souls of the redeemed [Cf. Lumen Gentium, 62; cf. Paul VI, Exhort. Apost. Signum Magnum, p. 1, n. 1].

PATRON AND CONNOISSEUR OF THE ARTS

Paul VI had a broad interest in the arts and devoted considerable time to reading about them as well. On May 7, 1964, less than a year after becoming pope, he invited artists to the Sistine Chapel in an attempt to bridge the gap between the Church and artists. (Paul had similarly sought to reestablish a dialogue and rapport with the working class in Milan, whom he felt had been alienated from the Church.) He told the artists that the Church needed them and pointed to the long history of collaboration between the Church and artists. He observed: "And if we were deprived of your assistance, our ministry would become faltering and uncertain, and a special effort would be needed, one might say, to make it artistic, even prophetic. In order to scale the heights of lyrical expression of intuitive beauty, priesthood would have to coincide with art."

Paul's effort to reestablish an ecclesial awareness or sensitivity and a dialogue with artists anticipated his encyclical on awareness, reform, and dialogue, *Ecclesiam Suam,* which was published three months later (August 6, 1964).

Prior to the eighteenth century, when literacy became more common, art had been a major component of the Church's catechesis, as biblical scenes were brought to life in an inspired manner conducive to learning, reflection, and prayer.

In modern times, the application of lectio divina to art has been rediscovered, with of course the classic Madonna and child paintings by luminaries such as Raphael and Bellini and biblical dramatizations by Fra Angelico, Giotto, Reubens, and Michelangelo, to name just a few, serving as centerpieces of this renaissance. These were a staple of Catholic piety during the latter middle ages and continue to offer possibilities for spiritual growth and edification.

Pope Paul, however, was not nostalgically fixated on a return to the glory days of Renaissance art. He was interested in collaboration with contemporary artists, and to that end, he assigned his secretary, Monsignor Pasquale Macchi, the responsibility of overseeing the decade-long development of a contemporary art collection in the Vatican Museum, which opened in 1974, and currently numbers around eight thousand pieces.

Monsignor Macchi wrote to artists all over the world and received abundant and generous replies. Artwork poured in from all over, far more than could be displayed at one time. A Vatican museum guard once told me that the museum possessed a huge surplus, which periodically would be rotated

Pieta, c.1890 (oil on canvas), Gogh, Vincent van (1853-90) / Vatican Museums and Galleries, Vatican City / Photo © Stefano Baldini / Bridgeman Images

into the visible collection. He also took me to a bronze 1965 sculpture of Paul VI that was currently not on display. I found the Vatican assortment to be one of the most tasteful and stimulating collections I have encountered. It stands as a testament to Paul VI's commitment to the integration of the arts with spirituality, to form what St. John Paul II would refer to as Catholic culture. More information and examples of the collection can be found on the website museivaticani.va.

A Return to Artistic Roots

St. John Paul II echoed Paul's appeal by issuing a letter to artists on Easter Sunday, April 4, 1999. It explores the underlying historical, philosophical, spiritual, and aesthetic dimensions in a reflective manner conducive to lectio divina. The letter in its entirety can be accessed on vatican.va under the apostolic letters of St. John Paul II.

Papal reflections and exhortations on the modern Church's rediscovery of the role of art in Catholic culture and spirituality would be in vain if we did not internalize it and bring it to life in our daily journeys, taking time to appreciate the beauty of others and nature, and rediscovering the unifying and evangelical dimension of beauty in our collective quest towards a peaceful, reverent, and loving coexistence. Modern papal reflections on art reveal to us how counterfeit art has gained prominence in the modern world and pushed beauty to the fringes. One of the tasks of modern religious sensibilities is to undo or reverse this tragic development and to reawaken in our world an appreciation for beauty that is reflective of its origins, God.

A Day in the Life of a Pope

On page 64 of *Paul VI: The Man and His Message,* his personal secretary, Pasquale Macchi, outlined Paul's daily routine. He awoke at 6:00 a.m., began the day with meditation and then Mass and the recitation of the Breviary (the Liturgy of the Hours). Morning audiences continued until 1:00 or 2:00 p.m. and Paul would grab lunch as he was able. His private audiences sometimes ran long because he allocated to people the time that he thought they needed. A characteristic of all the modern popes, and in fact most extraordinarily holy persons, is the sense of presence and availability that they project. When you speak to them, they convey

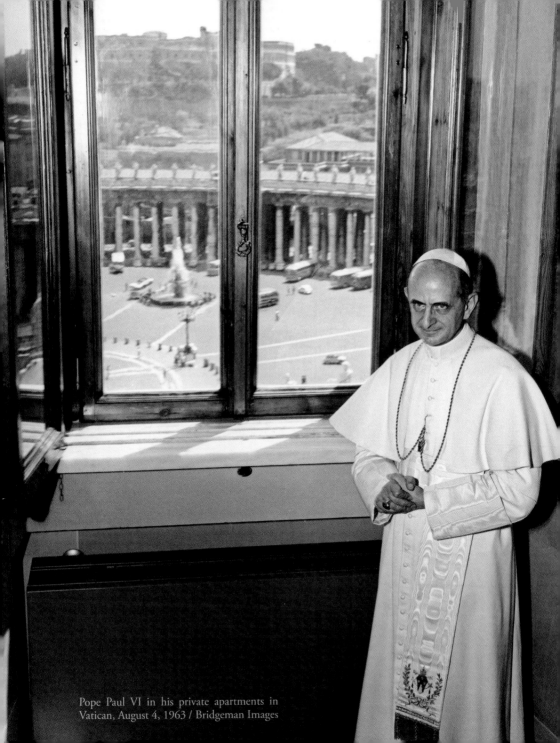

Pope Paul VI in his private apartments in
Vatican, August 4, 1963 / Bridgeman Images

the impression that you are the only person who exists in the world for them at that moment.

Paul took a daily afternoon nap, a habit he developed while working in the Secretariat of State. On awakening, he would continue with the Liturgy of the Hours (Vespers) in the papal chapel, then from 5:00 to 8:00 p.m., he would attend to paperwork and other official business or meetings with Vatican officials. A noteworthy and perhaps little-known fact is that Paul was generous with Vatican funds and would typically double the amount of charitable subsidies recommended by his secretary. That charitable impulse was part and parcel of his daily life and outlook.

He had dinner at 8:00 p.m. while watching the news on television, and then would recite the Rosary with his secretaries. He then continued working again until close to midnight, at which point he would recite Compline with his secretary and then work a bit longer until retiring between 1:30 and 2:00 a.m.

Wednesday Audiences

One of the regular activities of the pope is to conduct catechesis during his Wednesday audiences. Incidentally, Paul VI deserves credit for authorizing the building of the hall in 1971 from which those audiences are delivered and which now bears his name. (It is also sometimes referred to as the Hall of the Pontifical Audiences.)

Originally known as Nervi Hall, after the architect who designed it, it now has a seating capacity of 6,300 and a donated solar roof that received an award for solar architecture and urban development. Interestingly, the hall is in both the Vatican and Italy, perhaps symbolizing the connection to the world implicit in evangelization.

Paul received considerable criticism for this capital expense, but as with many other of his decisions, his foresight has been validated by time. During his pontificate, Paul continued and solidified the tradition of the Wednesday papal audiences, and these were compiled in yearly volumes published by the US Conference of Catholic Bishops. Paul prepared his talks the day before in his precise and minute handwriting after consulting the books that he had asked Monsignor Macchi and, later, Father John Magee, his English-speaking secretary, to bring him to aid in his preparations.

Paul's Papacy in Context

Chronicles and assessments of Paul's pontificate have been published since he became pope and more will appear now that he is newly canonized. What is missing is a realistic consideration of the cultural and ecclesial context in which he led the Church, and how that affected his teachings and decisions. What were the real possibilities before him, and what were the constraints? What can be tied to him, and what has its roots in the larger picture, and in the actions of others?

In placing Paul VI in context, we plug into one of the slogans not only of his papacy but of the council and its aftermath: "reading the signs of the times." John XXIII set the foundation for this, and Paul built upon it.

Pope Saint Paul was a prayerful and theologically astute mystic who was able to discern cultural and ecclesial currents and act prudently in response. He relied on the opinion of others but did not hide behind committees or commissions or even the council. He took seriously the powers of the papacy and discharged them as humbly and beneficially as he could.

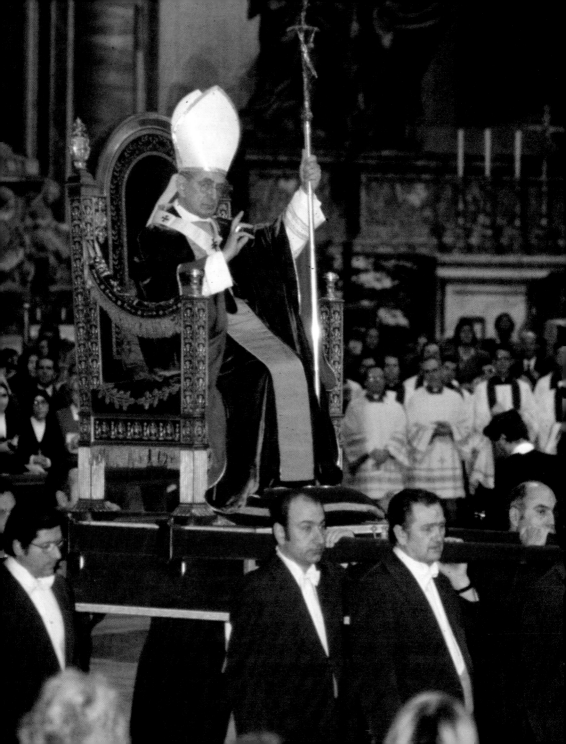

Pope Paul VI during Ash Wednesday Mass in Saint Peter's Basilica
in Rome (Vatican) February 1977 / Bridgeman Images

Paul VI spent much time discerning and assessing the cultural and ecclesial environments in which he operated, and thus while many of his decisions may have been unpopular, and some backfired to a degree, they also reflected a long-term perspective and a fundamental commitment to the unity of the Church and the integrity of the deposit of faith.

He was willing to issue contemporary versions of the Beatitudes and the Nicene Creed ("The Credo of the People of God", published on the feast of St. Peter and Paul less than a month before *Humanae Vitae*, and sadly overlooked in its wake), but he would not water them down or minimize them.

Paul gave people the freedom to utilize their gifts and exercise initiative in a responsible spirit of Christian liberty. Implicit was the expectation that the provisos and parameters that accompanied his efforts and innovations would likewise be present in the Church at large. Everyone is ultimately accountable to God, but we also have a responsibility to society, the Church, and especially those close to and dependent upon us. When, under the aegis of a vague "spirit of Vatican II," people pursued narrow agendas and distorted and betrayed the council's teachings and reforms, he experienced great consternation, but was hesitant to condemn and punish.

Those who view him as timid and vacillating fail to recognize that he was balancing many considerations while bearing in mind the long-term consequences of his actions. In hindsight, it is easy to second guess a pope who has the courage to make decisions under pressure and in imperfect circumstances. This is why the prophetic and far-seeing nature of Paul's decisions is so impressive. He stood tall against intimidating resistance and held fast to his principles and responsibilities.

It is much easier to "shoot from the hip" without much forethought

than to carefully consider all alternatives and then diligently pursue the path which seems most appropriate.

In the concluding section, we will see how the man rightly identified by biographer Peter Hebblethwaite as the first modern pope was truly a man of his times, as well as for all times, yet he did not become defined or confined by them.

Paul's final homily at St. Peter's, on the feast of St. Peter and Paul in 1978, fittingly ten years after his publication of a modern rendition of the Creed, communicates in a poignant epitaph the inner peace and consolation he experienced amid the tumult surrounding him: "As the last, and unworthy, successor of Peter, we feel at this extreme threshold comforted and supported by the conscience of having tirelessly repeated before the Church and the world: 'You are the Christ, the son of the living God,' and with Paul, we feel we can say, 'I have fought the good battle, run the race and kept the faith.'"

We can go beyond appreciation of Paul VI's reassuring self-affirmation and seek to actualize it in our lives through emulation of his humble, evangelical disposition and his undying love for Christ, the Church, and a world gone astray. His teachings, highlighted in the next chapter, can be an inspirational beacon along our paths.

Original Offense

16. We believe that in Adam all have sinned, which means that the original offense committed by him caused human nature, common to all men, to fall to a state in which it bears the consequences of that offense, and which is not the state in which it was at first in our first parents—established as they were in holiness and justice, and in which man knew neither evil nor death. It is human nature so fallen, stripped of the grace that clothed it, injured in its own natural powers and subjected to the dominion of death, that is transmitted to all men, and it is in this sense that every man is born in sin. We therefore hold, with the Council of Trent, that original sin is transmitted with human nature, "not by imitation, but by propagation" and that it is thus "proper to everyone" [Cf. Dz.-Sch. 1513].

Reborn of the Holy Spirit

17. We believe that our Lord Jesus Christ, by the sacrifice of the cross redeemed us from original sin and all the personal sins committed by each one of us, so that, in accordance with the word of the apostle, "where sin abounded, grace did more abound" [Cf. Rom. 5:20].

Baptism

18. We believe in one Baptism instituted by our Lord Jesus Christ for the remission of sins. Baptism should be administered even to little children who have not yet been able to be guilty of any personal sin, in order that, though born deprived of supernatural grace, they may be reborn "of water and the Holy Spirit" to the divine life in Christ Jesus [Cf. Dz.-Sch. 1514].

The Church

19. We believe in one, holy, catholic, and apostolic Church, built by Jesus Christ on that rock which is Peter. She is the Mystical Body of Christ; at the same time a visible society instituted with hierarchical organs, and a spiritual community; the Church on earth, the pilgrim People of God here below, and the Church filled with heavenly blessings; the germ and the first fruits of the Kingdom of God, through which the work and the sufferings of Redemption are continued throughout human history, and which looks for its perfect accomplishment beyond time in glory [Cf. Lumen Gentium, 8, 5]. In the course of time, the Lord Jesus forms His Church by means of the sacraments emanating from His plenitude [Cf. Lumen Gentium, 7, 11]. By these she makes her members participants in the Mystery of the Death and Resurrection of Christ, in the grace of the Holy Spirit who gives her life and movement [Cf. Sacrosanctum Concilium, 5, 6; cf. Lumen Gentium, 7, 12, 50]. She is therefore holy, though she has sinners in her bosom, because she herself has no other life but that of grace: it is by living by her life that her members are sanctified; it is by removing themselves from her life that they fall into sins and disorders that prevent the radiation of her sanctity. This is why she suffers and does penance for these offenses, of which she has the power to heal her children through the blood of Christ and the gift of the Holy Spirit.

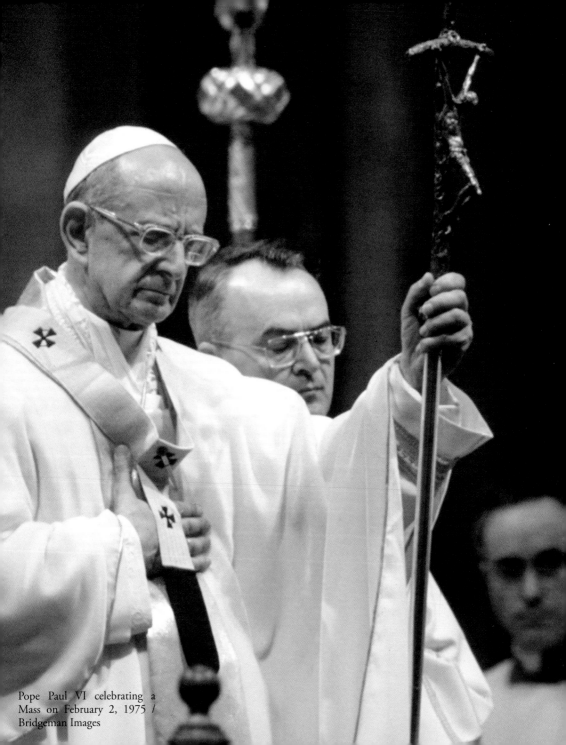

Pope Paul VI celebrating a
Mass on February 2, 1975 /
Bridgeman Images

Paul's Teachings

Pope St. Paul VI's teachings have notably maintained, if not prophetically deepened, their personal, pastoral, and magisterial relevance since his death. In some ways, their applications are more apparent and well-received than when originally published. For a long time, Paul's high-profile document *Humanae Vitae* has been considered prophetic, while *Populorum Progressio* and *Evangelii Nuntiandi* have retained their status, accorded unusually soon after publication, as being far-seeing standard works on their respective subjects. Subsequent papal teachings on social justice and evangelization inevitably make references to them. On June 22, 2013, Pope Francis referred to *Evangelii Nuntiandi* as "to my mind the greatest pastoral document that has ever been written to this day." In *Caritas in Veritate,* Pope Benedict XVI drew more extensively from *Populorum Progressio* than any previous pope had drawn from a predecessor's papal document.

The best way to assimilate Paul VI's teachings is chronologically, because Paul's publications naturally reflect developments in the Church and the world.

Paul's first encyclical, *Ecclesiam Suam,* set the tone for not only Vatican II but Paul's entire pontificate. It focused on three themes, conscience

and awareness, reform and renewal, and dialogue, and it reflected Paul's diplomatic acumen cultivated over decades in the Vatican's Secretariat of State.

This document is a masterpiece on Christian communications and is as vibrant and pertinent today as on the day of its publication, August 6, 1964, which was also coincidentally the day on which he died in 1978.

Dutch Treat

Paul's next major document was *Mysterium Fidei* (September 3, 1965) on the Holy Eucharist. It was issued toward the end of the council to combat the blurring of important doctrines and pastoral practices that were occurring in some circles, most notably in Holland.

The so-called Dutch (New) Catechism was widely disseminated and reflected the influence of two prominent Dutch theologians who had run afoul of the Sacred Congregation for the Doctrine of the Faith. The latter office also investigated the catechism and insisted on clarifications, which were subsequently inserted. *Mysterium Fidei* retains its value as a lucid document on Eucharistic theology as well as a judicious attempt to rein in certain theologically and liturgically adventurous elements within the Church.

The encyclical was overshadowed by the council, and the technical and abstract nature of much of it made it primarily of interest to the theologically sophisticated and pastorally affected. In a manner that would mark his pontificate, Paul addressed aberrations directly and firmly, but also gently and discreetly when possible. *Mysterium Fidei* continues to serve as a fine foundation and complement to St. John Paul II's *Ecclesia de Eucharistia* (April 17, 2003).

It is particularly enlightening and edifying to read papal documents

such as these because they also reflect the influence of a variety of distinguished theologians, topical experts, and insightful peers. Thus, we are getting authoritative Catholic/universal teaching in a reasonably accessible package. We may not comprehend everything right away, but by reading them according to the model of lectio divina, we can derive a meaning and application appropriate to us. These can serve as a trusty reference for ensuring that we are not only understanding but also living doctrines in a proper manner.

Fast Work

In 1966, one of Paul's most far-reaching initiatives was released, the Apostolic Constitution *Paenitemini,* his updating modification of the traditional abstinence laws. The media and cultural pattern of ignoring the substance of a document or initiative and focusing only on highlights, or perhaps distorted interpretations, once again emerged, causing one of the main themes of the document, penance, to be obscured, if not lost, in the publicity.

Unlike other papal initiatives, this one received favorable coverage from the secular media, who weren't typically interested in the reasons for fasting and abstinence, but were gratified that, in one respect anyway, the Church was seemingly moving away from tradition toward modern sensibilities. Perhaps that was a foreshadowing of future changes, and expectations were heightened. Of course, this characterization was a naïve over-simplification, but it worked for mass consumption. It failed to recognize that with respect to Paul's magisterium, the meat and essence was not only in his poignant gestures and idioms but in their underlying depth, indications, nuances, and syntheses. With Paul, as with any profound thinker, the whole is typically greater than the sum of the parts.

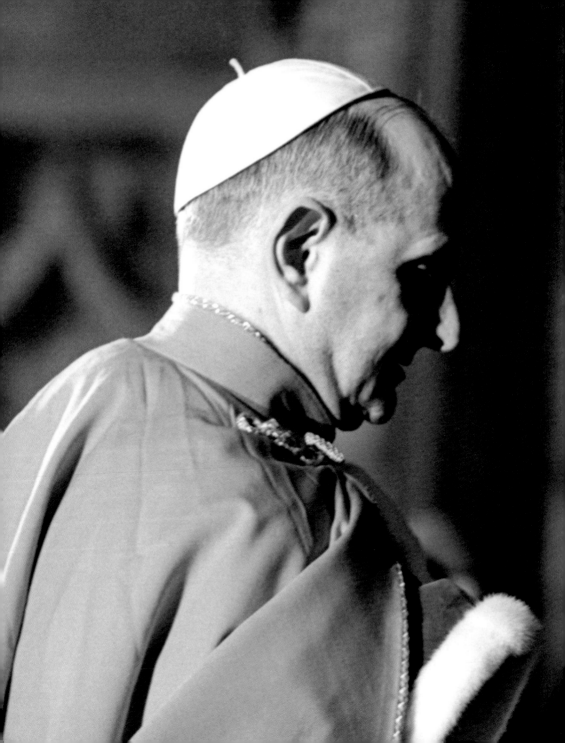

Pope Paul VI celebrating the Christmas Mass at Basilica of
Santa Croce, Florence, December 24th, 1967 (b/w photo) /
Mario De Biasi per Mondadori Portfolio / Bridgeman Images

Personalizing Asceticism

Paul freed Catholics from obligatory meatless Fridays with the proviso that they would substitute some other, ideally more personally meaningful, penance in remembrance of the love expressed on Good Friday. The fact that we are no longer obliged to go "meatless" on Fridays is universally known by Catholics and non-Catholics alike; that we are, however, urged to make some penitential sacrifice is, sadly, less so today. That said, many faithful Catholics do still practice an abstention or fast every Friday. What's past is passed, but there is nothing stopping us from taking Paul VI up on his ascetical invitation and trying to remember in a special way on Fridays the paschal mystery and what Christ's self-offering says to us today in our concrete circumstances. This is even more crucial when we are struggling or teetering spiritually or morally. We need built-in preventive safeguards to keep us on the straight and narrow—like Sunday Mass attendance and regular confession, for example.

Here, again, we encounter Paul's tendency to invite the faithful to assume adult responsibility for their praxis (faith in action). While many people ignored this to their and the Church's ultimate detriment, many others did not. Many respected and capitalized on the entrustment, viewing it as an inspired, good faith opportunity, took the initiative, and developed a more mature faith and participation in the Church's ascetic and devotional practices.

Subsidiarity in the Church

This attitude of empowering people and making them responsible highlights another aspect of Paul's papacy, the principle of subsidiarity that he fostered. Paul VI was every bit as strict about doctrine as St. John Paul II and Benedict XVI, but his administration was not as rigorous

in its monitoring procedures and disciplinary actions. It was a different time. Of course, someone can be orthodox in theory while deviating in practice, thereby setting a bad example and perhaps even scandalizing others. This is why the Bible is rigorous in its demands on those in authority or with catechetical responsibilities. To whom more is given, more is expected.

In the spirit of divine mercy and patience underlying the parable of the wheat and the tares (cf. Mt 13:24–30), Paul VI was willing to run the risks of bad eggs getting mixed in with the good ones. He seemed to recall that Jesus put his Church in human hands, giving the apostles, and particularly Peter, authority on heaven and earth, knowing full well it would be exercised imperfectly. There will always be a healthy, and sometimes unhealthy, tension between respect for authority and that authority's respect for liberty of action on the part of the faithful. The history of the Church over the past fifty years, with both its crises and its flowering of new, creative initiatives, illustrates this point all too well.

Ultimately, people have freedom, and, it seems that Paul's view was that it is better overall to empower them and assume the risks rather than discourage or repress them. We are called to trust people, including ourselves, as well as God. Ideologically-driven, a-contextual evaluations of Vatican II have a tendency to either exaggerate or minimize the fruitful applications and implementations, and the accompanying empowerment that occurred. Paul's next major document, on human development, would address the issue head on.

The Annunciation by Boulogne, Restored Traditions

Marian Devotional Encyclicals

However, interspersed between *Mysterium Fidei* and Paul's most influential encyclical, *Populorum Progressio,* were two Marian encyclicals: *Mense Maio* ("Month of May," April 29, 1965) and *Christi Matri* ("Mother of Christ," September 15, 1965). These focused on particular aspects of Marian devotion, and reflected both Paul's Marian spirituality as well as his sensitivity to ecumenical concerns and Tradition. He possessed the capacity to articulate Marian doctrines and practices in a precise manner that clarified potentially confusing or ambiguous theological issues and pastoral practices. In 1974, Paul VI would issue a comprehensive apostolic exhortation on devotion to Mary that serves as an interesting complement to St. John Paul II's various Marian documents.

Populorum Progressio

On March 26, 1967, Paul VI published his most widely praised encyclical, *Populorum Progressio,* "On the Development of Peoples," which also drew attention in secular circles for its teachings on economic justice, which were rather novel at that time. The distinguished French economist Francois Perroux commented: "It is one of the greatest texts of human history. It radiates a kind of rational, moral, and religious testimony . . . a profound and original synthesis of the Ten Commandments, the Gospel teaching and the Declaration on Human Rights." Not everyone agreed, because it took aim at established policies and structures sustained by powerful interests.

As outlined in Hebblethwaite's biography *Pope Paul VI: The First Modern Pope* (p. 483) and in the blog cardijnresearch.blogspot.com, the French Dominican Louis-Joseph Lebret, whose writings Paul VI admired and who had contributed as a peritus (expert observer) to the

council document *Gaudium et Spes*, was consulted by Paul VI during his initial research and draft of the document, and his work is reflected in the document even though he died the year before. Paul stated that the document would be a tribute to his memory.

Section 14 of *Populorum Progressio* asserts: "The development We speak of here cannot be restricted to economic growth alone. To be authentic, it must be well rounded; it must foster the development of each man and of the whole man. As an eminent specialist on this question has rightly said: 'We cannot allow economics to be separated from human realities, nor development from the civilization in which it takes place. What counts for us is man—each individual man, each human group, and humanity as a whole.'" The referenced citation was from Lebret's 1961 book *Dynamique concrète du développement* (Paris: Economie et Humanisme, Les editions ouvrierès, 1961, 28).

This document linked individual and communal development and became a cornerstone of modern Catholic social teaching. Subsequent episcopal and papal documents on social justice have drawn extensively from it, especially *Caritas in Veritate* (June 29, 2009), as mentioned previously.

Third world (especially Latin American) Catholics were particularly appreciative of *Populorum Progressio* because it recognized structural injustices and insisted on their correction according to Christian principles. Reaction was less favorable in other outlets—often those associated with strong financial interests—in fact were highly critical because it excoriated what St. John Paul II would later identify as savage capitalism. Some labeled the document as pseudo-socialist, but Paul VI was too orthodox, theologically acute, balanced, and literarily precise to justify such concerns and labels.

On a more personal and practical level, *Populorum Progressio* offered a Christian alternative to the secular humanism of the self-help movement and the prosperity Gospel that has evolved in Christian circles.

The Discipline of Celibacy

Several months later, on June 24, 1967, the pope addressed the subject of priestly celibacy in *Sacerdotalis Caelibatus*. His affirmation of mandatory clerical celibacy came as a disappointment to many whose expectations had been raised in the aftermath of the council and in light of massive resignations from the priesthood and religious life. As with the issue of birth control, the media buzz was also out of step with papal indications, thereby imparting a false hope to those inclined toward a radical change.

Many people blame Paul VI and the council for this mass exodus, but many others recognize that numerous factors were involved, including historical conditions and subsequent sociological developments. First, many priests were not properly prepared for their ministry. Furthermore, fewer and fewer parents, especially mothers, were willing to encourage their children toward the priesthood or religious life because of socio-economic and cultural developments that had shaken the roots of family life. After the Great Depression and World War II, families were inclined to reserve talented children for the support of the household. Work and educational opportunities were gradually opening up, and in the wake of the cultural revolutions of the sixties, there was declining prestige associated with the priesthood. In the 1950s, when priests in their clerical garb went to attractions such as the movies, they were often waved in: "Go right ahead, Father." Obviously, that is not the case today.

Thus, perhaps some less qualified persons sought the priesthood, and, given the tumult of the times in general and within the Church

in particular, consequently in their individual vocations their foundation and identity was shaken. These reasons certainly do not explain all the departures, let alone justify them, but they are factors nonetheless. Initiatives and decisions by Paul VI and the aftereffects of the council certainly affected clergy and religious, but this could be in a positive as well as negative manner. It made the unstable teeter but also challenged the complacent and expanded the horizons of those willing to grow in their faith.

The media and secular culture naturally reacted with disapproval because for them chastity is an antiquated absurdity. Reaction varied within the Church because this was a changeable element of Tradition, since mandatory celibacy had only existed in the western Church since the twelfth century.

The debate continues today, as there are many priests and religious who believe celibacy is proper to the vocation, while others are less certain.

We should also not forget Paul's restoration of the permanent diaconate on June 18, 1967 through the Apostolic Letter given *Motu Proprio* (by his own motivation; that is, not necessarily in response to an external prompt) *Sacrum Diaconatus Ordinem*, which has spawned within the permanent diaconate community an appreciation of and gratitude towards Paul VI, and a deep respect for his magisterium.

(*opposite*) Pope Paul VI coming out of the Baptistry of Saint John where he wore the vestments for the Christmas Mass, Florence, December, 24th, 1967 (b/w photo) / Mario De Biasi per Mondadori Portfolio / Bridgeman Images

The Word

20. Heiress of the divine promises and daughter of Abraham according to the Spirit, through that Israel whose scriptures she lovingly guards, and whose patriarchs and prophets she venerates; founded upon the apostles and handing on from century to century their ever-living word and their powers as pastors in the successor of Peter and the bishops in communion with him; perpetually assisted by the Holy Spirit, she has the charge of guarding, teaching, explaining and spreading the Truth which God revealed in a then veiled manner by the prophets, and fully by the Lord Jesus. We believe all that is contained in the word of God written or handed down, and that the Church proposes for belief as divinely revealed, whether by a solemn judgment or by the ordinary and universal magisterium [Cf. Dz.-Sch. 3011]. We believe in the infallibility enjoyed by the successor of Peter when he teaches ex cathedra as pastor and teacher of all the faithful [Cf. Dz.-Sch. 3074], and which is assured also to the episcopal body when it exercises with him the supreme magisterium [Cf. Lumen Gentium, 25].

21. We believe that the Church founded by Jesus Christ and for which He prayed is indefectibly one in faith, worship and the bond of hierarchical communion. In the bosom of this Church, the rich variety of liturgical rites and the legitimate diversity of theological and spiritual heritages and special disciplines, far from injuring her unity, make it more manifest [Cf. Lumen Gentium, 23; cf. Orientalium Ecclesiarum 2, 3, 5, 6].

22. Recognizing also the existence, outside the organism of the Church of Christ, of numerous elements of truth and sanctification which belong to her as her own and tend to Catholic unity [Cf. Lumen Gentium, 8], and believing in the action of the Holy Spirit who stirs up in the heart of the disciples of Christ love of this unity [Cf. Lumen Gentium, 15], we entertain the hope that the Christians who are not yet in the full communion of the one only Church will one day be reunited in one flock with one only shepherd.

Jesus the good shepherd (photo) / Godong/ UIG / Bridgeman Images

23. We believe that the Church is necessary for salvation, because Christ, who is the sole mediator and way of salvation, renders Himself present for us in His body which is the Church [Cf. Lumen Gentium, 14]. But the divine design of salvation embraces all men; and those who without fault on their part do not know the Gospel of Christ and His Church, but seek God sincerely, and under the influence of grace endeavor to do His will as recognized through the promptings of their conscience, they, in a number known only to God, can obtain salvation [Cf. Lumen Gentium, 16].

Pope Paul VI during Mass for consecration of new bishops in
January 1969. Photo © Patrick Morin / Bridgeman Images

Paul's Believe It or Not

The summer of 1968 was a busy one for Paul VI in terms of publications. On June 30, he published the *Credo of the People of God*, a contemporary version of the Creed into which he put considerable effort. His mentor and friend Jacques Maritain, a prominent French philosopher, also contributed significantly to the Creed.

It is presented in sections throughout this book in its entirety as a handy catechetical aid and prayer stimulus, something to reflect on and wrestle with.

What do I believe, and why? What difference does it make in my life? Do I want to know more about my faith, and really understand and practice it, or am I satisfied with an adolescent level of religious knowledge and maturity, juxtaposed perhaps to an encyclopedic knowledge of sports or celebrity trivia and trends? This can be a new beginning or refresher course for each of us, courtesy of our newest pope saint. It can reacquaint us with the ever new discovery that our Faith is even more profound and beautiful than we realized.

A Creed and Catechism

It is interesting and noteworthy that Pope Paul VI published a creed, which was largely eclipsed by the forthcoming *Humanae Vitae*, while St. John Paul II published a catechism which was widely disseminated and dissected, though it was obviously much bulkier and more comprehensive. Perhaps these respective initiatives also reveal something about the governing styles of these pontiffs or their own reflections on what was needed at the time. Paul VI published a creed which supplies the basics and invites the believer to fill in the gaps. St. John Paul II published a catechism which left little to speculation or innovation.

Differences in Method and Style

Pope St. Paul VI believed in empowering others and trusting them to be responsible and faithful. Pope St. John Paul II put more controls in place, seeking to ensure that no unintended misunderstandings or deviations occurred. The former was an Italian diplomat who endured fascism. The latter was a Polish intellectual who endured Nazism and Communism. Both were products of their times and read the signs of the times as best they could. Different times, different measures, same goals. At the risk of over-simplification, Paul VI was diplomatically precise and cautious in his statements, fully aware of nuances and contingencies and the subjectivity involved in interpreting his teachings, while St. John Paul II was demonstrably self-assured, assertive, and philosophical. Each man communicated his message in accord with his capacities, magisterial obligations, and pastoral circumstances.

The latter's attributes are particularly apparent in his exhaustive Theology of the Body presentations (1979–84), which go into great depth in their exposition of the biblical creation narratives and related texts. Paul VI tended to not focus on one topic that extensively. Each week he would come up with a new topic or angle, though typically there was continuity and progression of thought. Though their backgrounds, approaches, and personas were dramatically different, the man who was secretary to both, Fr. John Magee, observed: "Having lived with John Paul II and having listened to him publicly and privately, I must say that you could never get two popes who were as close in their thinking as Paul VI and John Paul II."

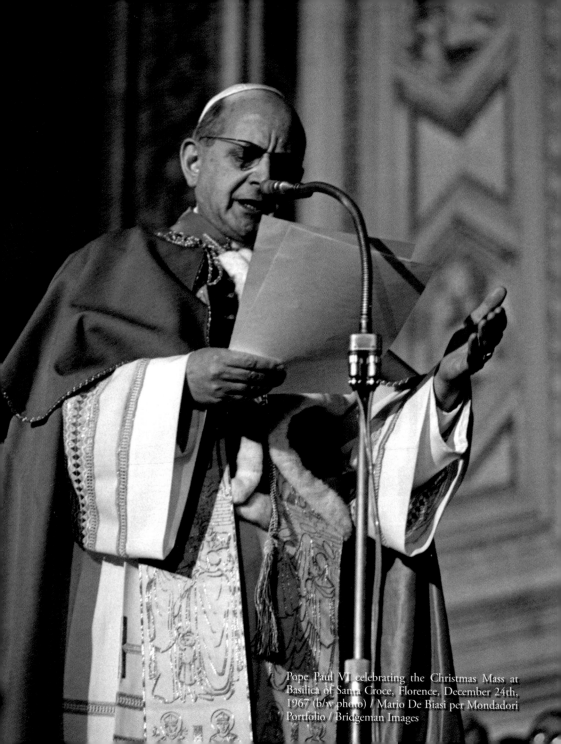

Pope Paul VI celebrating the Christmas Mass at
Basilica of Santa Croce, Florence, December 24th,
1967 (b/w photo) / Mario De Biasi per Mondadori
Portfolio / Bridgeman Images

Humanae Vitae

July 25, 1968. The newspaper headlines focused only on the affirmed ban of contraception and ignored the beautiful teaching on marriage and pastoral care of married couples. The media generally failed to acknowledge that until 1930 virtually all the major Christian denominations opposed contraception. The Anglican Church's Lambeth Conference gave conditional approval to contraception in special circumstances, which in practice inevitably spawned perplexing gray areas and outright abuses. Paul VI likely had that in mind while he pondered relaxing the prohibition on a conditional basis.

On July 31, during the first Wednesday audience at Castel Gandolfo after the publication of *Humanae Vitae,* Paul acknowledged that he had researched the issue exhaustively, from almost every moral, theological, sociological, and biological angle, and that he was relieved to have finally made a decision, and have that behind him . . . or so he thought:

> The first feeling was that of a very grave responsibility. It led Us into and sustained Us in the very heart of the problem during the four years devoted to the study and preparation of this Encyclical. We confide to you that this feeling caused Us much spiritual suffering. Never before have We felt so heavily, as in this situation, the burden of our office. We studied, read and discussed as much as We could; and We also prayed very much about it.
>
> How often have We felt almost overwhelmed by this mass of documentation! How many times, humanly speaking, have We felt the inadequacy of Our poor person to cope with the formidable apostolic obligation of having to make a pronouncement on this matter!

> How many times have We trembled before the alterna-
> tives of an easy condescension to current opinions, or of a
> decision that modern society would find difficult to accept,
> or that might be arbitrarily too burdensome for married life!

He also acknowledged that he did not intend *Humanae Vitae* to be the final word on the subject: "It [*Humanae Vitae*] clarifies a fundamental chapter in the personal, married, family and social life of man, but it is not a complete treatment regarding man in this sphere of marriage, of the family and of moral probity. This is an immense field to which the Magisterium of the Church could and perhaps should return with a fuller, more organic and more synthetic exposition."

He counted on the understanding of married couples and expected them to be supported as well:

> We hoped that Christian husbands and wives would under-
> stand that Our decision, however severe and arduous it may
> seem, is the interpreter of the genuineness of their love, called
> to be transformed by the imitation of the love of Christ for
> his mystical spouse, the Church. We hoped that they would
> be the first to support every practical move to assist the family
> in its needs, to make it flourish in its integrity, and to infuse
> into the family of today its own proper spirituality, a source of
> perfection for its individual members and a moral witness in
> society (cf. Apost. Actuous. n. 11; Gaudium et Spes n. 48).

Almost two years after the promulgation of *Humanae Vitae*, in his profound pastoral address on May 4, 1970 to the Teams of Our Lady, Paul observed:

And "with fear and trembling," but also with wonder and joy, husband and wife discover that in their marriage, as in the union of Christ and the Church, the Easter mystery of death and resurrection is being accomplished.

This does not all mean that husbands and wives are shielded against all failures: "Let him who prides himself on standing take care lest he fall." They are not freed from the need of persevering effort, sometimes in cruel circumstances that can only be endured by the realization that they are participating in Christ's passion.

But as is all too apparent, even in today's headlines, the sad fact remains that the beauty of the encyclical's teaching was, sadly, lost in many respects amid the distortion and hostility with which it was received in so many influential quarters, both within the Church and without.

Paul had a similar experience with respect to his relaxation of the abstinence laws on Fridays in the Apostolic Constitution *Paenitemini*. He posited that some other penance be substituted, but again often only a much distorted version got through.

There were valid reasons for Paul's long deliberation over the subject, as he readily acknowledged. Some commentators felt that given his background and temperament, Paul VI was more suited to address the subject of marriage in general terms. However, his indecisive reputation belied an agile mind conscious of contingencies and nuances and aware of the importance of balancing contrasting factors. He was deeply cognizant of human weakness and the ambiguities of life and providence. He made his decision with confidence and humility but also with an underlying trepidation. His responsibility was grave.

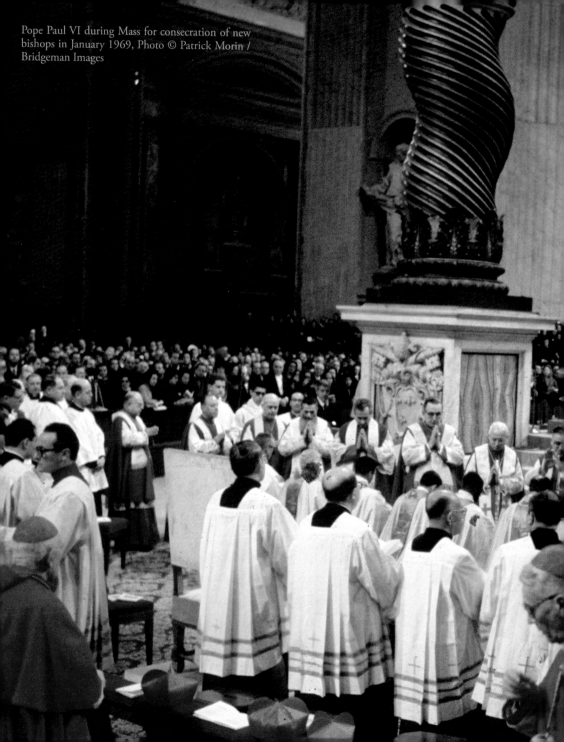

As alluded to previously, Paul VI provides a partial solution to this dilemma in the encyclical, and he is seldom given credit for it, but perhaps this isn't so unfair because it didn't originate with him. Given the state of affairs and the realities of life "on the ground," Paul VI, in *Humanae Vitae*, instructed confessors to be respectful and gentle with regard to this issue:

> Now it is an outstanding manifestation of charity toward souls to omit nothing from the saving doctrine of Christ; but this must always be joined with tolerance and charity, as Christ Himself showed in His conversations and dealings with men. For when He came, not to judge, but to save the world, (cf. Jn 3:17) was He not bitterly severe toward sin, but patient and abounding in mercy toward sinners?
>
> Husbands and wives, therefore, when deeply distressed by reason of the difficulties of their life, must find stamped in the heart and voice of their priest the likeness of the voice and the love of our Redeemer.
>
> So speak with full confidence, beloved sons, convinced that while the Holy Spirit of God is present to the magisterium proclaiming sound doctrine, He also illumines from within the hearts of the faithful and invites their assent. Teach married couples the necessary way of prayer and prepare them to approach more often with great faith the Sacraments of the Eucharist and of Penance. Let them never lose heart because of their weakness. (*Humanae Vitae*, no. 29)

The concluding pastoral directives section of the encyclical serves as a contextualizing cushioning of the first section, which is rather heady

and abstract, and theologically and pastorally a bit foreboding. Paul VI understood the challenges faced by modern couples struggling to live up to God's law in this regard and was primarily responsible for writing this section. His sensitivity and compassion shines through in what many consider the high point of the entire encyclical, belonging in the rarefied class of St. John Paul II's tender outreach in the encyclical *Evangelium Vitae* (no. 99) to women who have had an abortion, reassuring them that nothing is definitively lost.

Arguably, the second part of section 25 is the pastoral summit of the encyclical, and it can be readily applied to moral challenges other than contraception. When we fall, we are tempted to get discouraged, but we must remember that even the just person falls seven times a day but rises again (cf. Prv 24:16). Note Paul VI's discretion as he doesn't mention contraception by name:

> We have no wish at all to pass over in silence the difficulties, at times very great, which beset the lives of Christian married couples. For them, as indeed for every one of us, "the gate is narrow and the way is hard, that leads to life." Nevertheless it is precisely the hope of that life which, like a brightly burning torch, lights up their journey, as, strong in spirit, they strive to live "sober, upright and godly lives in this world," knowing for sure that "the form of this world is passing away."
>
> For this reason husbands and wives should take up the burden appointed to them, willingly, in the strength of faith and of that hope which "does not disappoint us, because God's love has been poured into our hearts through the Holy Spirit who has been given to us." Then let them implore the

help of God with unremitting prayer and, most of all, let them draw grace and charity from that unfailing fount which is the Eucharist.

If, however, sin still exercises its hold over them, they are not to lose heart. Rather must they, humble and persevering, have recourse to the mercy of God, abundantly bestowed in the Sacrament of Penance.

In this way, for sure, they will be able to reach that perfection of married life which the Apostle sets out in these words: "Husbands, love your wives, as Christ loved the Church. . . . Even so husbands should love their wives as their own bodies. He who loves his wife loves himself. For no man ever hates his own flesh, but nourishes and cherishes it, as Christ does the Church. . . . This is a great mystery, and I mean in reference to Christ and the Church; however, let each one of you love his wife as himself, and let the wife see that she respects her husband." (*Humanae Vitae*, no. 25)

Paul's Compassionate Passion Principle

Worth noting here is that the pope seems to be telling couples who are not following God's law as they should to not lose heart, but rather to take refuge in the sacraments and perseverance, in the hopes that they will reach the summit of marital love which is spelled out so beautifully in Ephesians 5:21–33.

What Paul proclaimed is rather extraordinary and hearkens us back to Jesus's encounters with various outcasts and noted sinners in the Gospels. The praying publican surpasses the proud Pharisee. The adulterous woman is restored and along with her accusers is admonished. Jesus's

pointed healing question—"Woman, where are they? Has no one condemned you?" (Jn 8:10)—rings true for all generations of repentant sinners. His message was that couples struggling to live Godly lives with respect to their marital relations and perhaps not measuring up to the Church's moral requirements nonetheless should continue the struggle, have frequent recourse to the sacrament of Penance for the grace and strength they need in addition to that forgiveness and inner peace for which every person longs (Phil 4:7).

No sin is beyond God's mercy. We sinners forget that when we are immersed in guilt, denial, or chronic immorality. Paul VI doesn't just stop at divine mercy, because he knows that God wants us to be all we can be, individually and together (cf. *Populorum Progressio*), and he tells us that if we keep trying, and even if we don't totally succeed, God will fill in the gaps and help us journey toward Christian perfection, with the analogy of Christ's love for the Church being a fitting metaphor. Perhaps above all, he anticipated John Paul II's exhortation for the faithful to always hope and to "be not afraid."

Expectations and Context

With the fiftieth anniversary of *Humanae Vitae* upon us, dissenting articles continue to be published that resemble those issued at the time. In light of what has transpired over the last half-century, one would expect to see more widespread recognition of the prophetic nature of his assertions. Critics continue to overlook the pastoral directives sections where he offered assurances and consolation for those having difficulty. What more do the militant detractors of *Humanae Vitae* want? Paul recognized there would be disagreement, but he rightly expected a substantial degree of conformity and respect.

In the post-conciliar years the concept of the primacy of an informed conscience was frequently (often loosely or theologically incorrectly) invoked as a determining factor in conformance to the encyclical, but that in no way mitigates the need for frequent confession (as the pope himself emphasized) and ongoing discernment and spiritual guidance, so that, as the pope says, even those struggling with conformance will eventually "for sure" reach the perfection of married life spelled out by St. Paul in his letter to the Ephesians. Bold and encouraging words from a pontiff, "for sure."

Magisterial Fallout

In any event, as is frequently noted, Paul never issued another encyclical, after producing seven in five years, and it has been reasonably concluded by many that Paul VI took the furor and opposition to his decision personally, particularly with respect to the bishops' conferences whose support he counted on. We forget that the pope is as human as the next man, and has feelings, fears, and foibles like the rest of us . . . yes, even a saint!

Paul took his rejection hard, but he rarely spoke of his inner feelings. He frequently bemoaned the distortion, faulty interpretations, and adaptations of Vatican II that ensued as well as the accompanying disrespect for papal authority, and the way secular attitudes were infiltrating the Church. Still, he never became embittered, and didn't stop writing superb documents, even if he didn't issue them as encyclicals.

An argument can be made that his post-*Humanae Vitae* writings were every bit as profound and enriching as his previous ones, though their influence may not have been quite as great due to the topics addressed. As we take leave of this pivotal juncture of his papacy, we can see that

Paul did not let his detractors get him down. Rather, he continued to read and respond to the signs of the times and do his best to steer the Church faithfully in the turbulent post-conciliar era.

Humanae Vitae's *Pastoral Complement*

Before we tackle Paul's next significant document, we will briefly consider a talk on marital love and spirituality that he gave almost two years after *Humanae Vitae* and which remains among the most insightful and inspirational pastoral discourses on marriage ever given by a modern pope, rivaling even St. John Paul II's Theology of the Body talks in terms of pastoral insight and moral paraenesis. A book containing both the encyclical and discourse and entitled *Good News About Marital Love* was published by the Liturgical Press in 1974. It was certainly aptly named.

As mentioned earlier, on May 4, 1970, Paul VI addressed a gathering of married couples in Rome celebrating the twenty-fifth anniversary of their movement, the Teams of Our Lady. The group consists of married couples who meet at each others' houses and share a meal and discussion with input from a priest.

Paul's talk was noteworthy for its length (over five thousand words), breadth, and pastoral sensitivity. In tone, it was the polar opposite of *Humanae Vitae*: much less formal, doctrinal, and intense, but of course no less morally rigorous. It reads like an inspiring and instructive marriage retreat and shows that Paul VI was much more in touch with the struggles of married couples than was generally acknowledged.

Sacrifice of Calvary

24. We believe that the Mass, celebrated by the priest representing the person of Christ by virtue of the power received through the Sacrament of Orders, and offered by him in the name of Christ and the members of His Mystical Body, is the sacrifice of Calvary rendered sacramentally present on our altars. We believe that as the bread and wine consecrated by the Lord at the Last Supper were changed into His body and His blood which were to be offered for us on the cross, likewise the bread and wine consecrated by the priest are changed into the body and blood of Christ enthroned gloriously in heaven, and we believe that the mysterious presence of the Lord, under what continues to appear to our senses as before, is a true, real and substantial presence [Cf. Dz.-Sch. 1651].

Transubstantiation

25. Christ cannot be thus present in this sacrament except by the change into His body of the reality itself of the bread and the change into His blood of the reality itself of the wine, leaving unchanged only the properties of the bread and wine which our senses perceive. This mysterious change is very appropriately called by the Church transubstantiation. Every theological explanation which seeks some understanding of this mystery must, in order to be in accord with Catholic faith, maintain that in the reality itself, independently of our mind, the bread and wine have ceased to exist after the Consecration, so that it is the adorable body and blood of the Lord Jesus that from then on are really before us under the sacramental

Pope Paul VI during Mass for consecration of new bishops in January 1969 here with Cardinal Karol Wojtyla (future John Paul II). Photo © Patrick Morin / Bridgeman Images

species of bread and wine [Cf. Dz.-Sch. 1642, 1651-1654; Paul VI, Enc. Mysterium Fidei], as the Lord willed it, in order to give Himself to us as food and to associate us with the unity of His Mystical Body [Cf. S. Th., 111, 73, 3].

26. The unique and indivisible existence of the Lord glorious in heaven is not multiplied, but is rendered present by the sacrament in the many places on earth where Mass is celebrated. And this existence remains present, after the sacrifice, in the Blessed Sacrament which is, in the tabernacle, the living heart of each of our churches. And it is our very sweet duty to honor and adore in the blessed Host which our eyes see, the Incarnate Word whom they cannot see, and who, without leaving heaven, is made present before us.

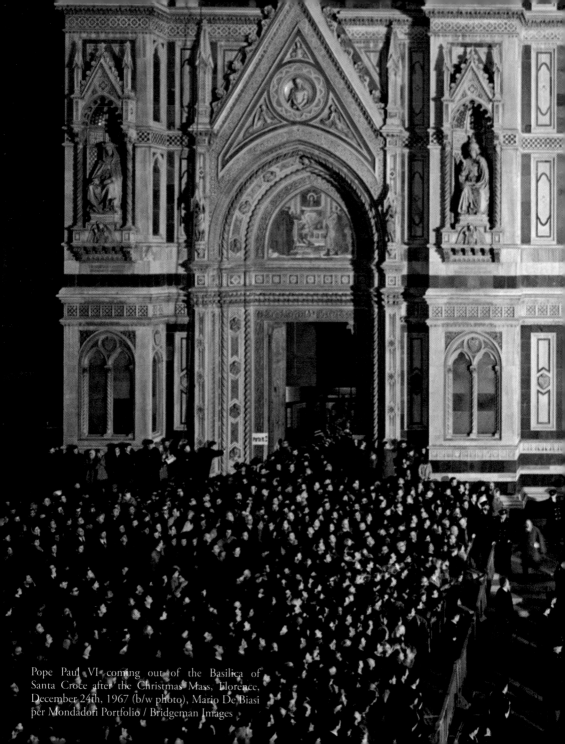

Pope Paul VI coming out of the Basilica of
Santa Croce after the Christmas Mass, Florence,
December 24th, 1967 (b/w photo), Mario De Biasi
per Mondadori Portfolio / Bridgeman Images

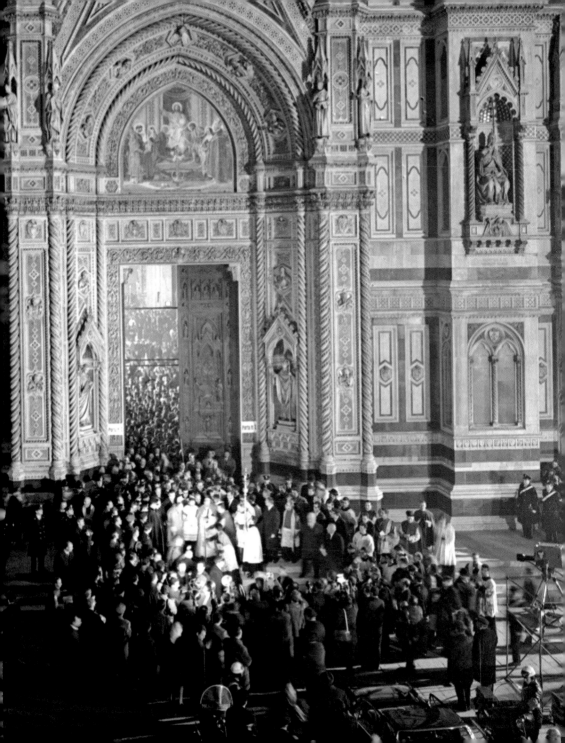

Roots and Preliminaries to Reform

On April 4, 1969, Paul VI issued one of his most consequential documents, amazingly succinct for its purposes, an Apostolic Constitution entitled *Missale Romanum*. This introduced what has come into the vernacular as the (New) Mass of Paul VI, in Latin the *novus ordo*.

Modern liturgical reform is best understood as a gradual process jump started under Pius XII with the influential encyclical *Mediator Dei,* which was issued on November 20, 1947. The next major step occurred at the Vatican Council, with the publication of the Constitution on the Sacred Liturgy during the second session. This authorized the translation of the traditional Latin Mass into the vernacular, and eventually led to the rite of the new Mass.

This gives us occasion to give just due to Pius XII, who is rightly credited with laying the groundwork for Vatican II with three influential encyclicals that eventually bore fruit in major conciliar constitutions.

Mystici Corporis Christi, "On the Mystical Body of Christ," had a significant impact on the two constitutions on the Church, *Lumen Gentium* and *Gaudium et Spes. Divino Afflante Spiritu,* "On Promoting Biblical Studies," eventually gave rise to *Dei Verbum*, the Dogmatic Constitution on Divine Revelation, and as discussed, *Mediator Dei* led to the Constitution on the Sacred Liturgy.

On April 21, 1964, Pope Paul VI approved a document by the Pontifical Biblical Commission, "On the Historical Truth of the Gospels," which helped pave the way for the approval of *Dei Verbum* by authenticating the practice of redaction criticism, which involves comparing parallel passages in the Synoptic Gospels and factoring in their historical contexts and pastoral objectives so as to better understand the intent of the evangelist and the text's original meaning. It approved the three-stage

theory of the Gospel message—Jesus's ministry, the apostolic preaching, and the written Gospels—which had been accepted in scholarly circles for some time. This affirmed the freedom and encouragement accorded scholars in *Divino Afflante Spiritu* to apply the historical critical method in a responsible fashion.

Paul VI also helped to reinstate Fr. Stanislaus Lyonnet and Fr. Max Zerwick, two prominent Jesuit professors at the Pontifical Biblical Institute whose teaching privileges had been suspended due to opposition from certain Roman academics who resisted the ongoing implementation of *Divino Afflante Spiritu*. An interesting doctoral thesis that chronicles Paul VI's teachings on the historical truth of the Gospels was published in 1997 by Fr. Brian Harrison, OS, and is entitled *The Teaching of Pope Paul VI on Sacred Scripture*.

Paul VI worked closely with Pius XII in the Secretariat of State and in many ways was his protege. Both were deeply intellectual and did not project well before crowds. In particular, Paul VI's personal warmth was belied by his shy public persona.

It is interesting to note that Pius XII published forty-one encyclicals in his nineteen-year pontificate, while Paul published seven in fifteen years. This gives us a good indication of how deeply Paul VI was affected by the controversy surrounding *Humanae Vitae*.

Both popes were in perilous positions during turbulent times (Paul in the aftermath of the council, and Pius XII during World War II) and endured harsh criticism. Paul VI made public comments in defense of Pius XII in response to the slanderous portrayal of Pius XII as anti-Semitic by playwright Rudolf Hochhuth in the 1962 play *The Deputy*. When false accusations against Paul were published in an underground Italian magazine, the issues of which were quickly confiscated by the

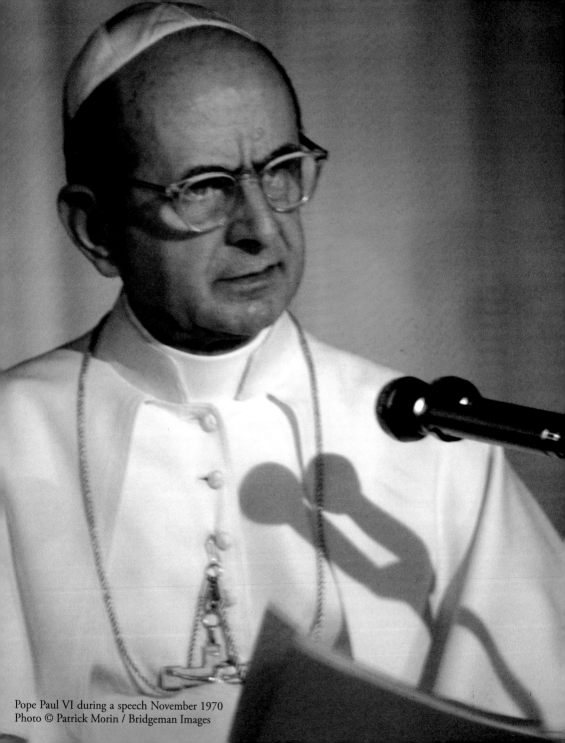

Pope Paul VI during a speech November 1970
Photo © Patrick Morin / Bridgeman Images

police, he requested prayers from the faithful and received an encouraging outpouring of support. Both Francis and Benedict have been effusive in their praise of Paul VI, and together have taken steps that have resulted in him being raised to the altar.

As fundamental a change as a liturgical overhaul was bound to evoke opposition. And it certainly has, much of it warranted at least with respect to its implementation. However, the liturgical renewal Paul facilitated, or hoped to facilitate, was grounded in tradition, but adapted to the needs of the people and the times. It was in the spirit of *aggiornamento,* or updating, in which St. John XXIII had called the council.

The Revised Lectionary

One aspect of the liturgical renewal which has received almost universal approval has been the updating and expansion of the lectionary. Several Protestant denominations have adopted it with modifications. Tweaking of the rite of the Mass has occurred on several occasions since its original overhaul in 1969, but other than updating the Bible translation and modifying the calendar, the lectionary has remained substantially unchanged. Reflections on the Sunday readings using the process of lectio divina has become a staple of spiritual devotion for many persons.

Several of the liturgical modifications, such as the exchange of the sign of peace, were reinstitutions of ancient practices with direct roots in biblical teachings.

Mixed Marriages

In 1970, Paul VI published an Apostolic Letter entitled *Matrimonia Mixta.* It provided guidance to couples on the dynamics and sacramental rubrics involved in the marriage of a Catholic to a non-Catholic.

The document points out that marriage is a human right, and thus the Church does not intend to stand in its way. However, in order that it be sacramental, certain criteria apply. Couples with religious differences who are considering marriage would be wise to consult it.

Localizing Populorum Progressio

On May 14, 1971, Paul VI issued *Octogesima Adveniens* ("A Call to Action"), a follow-up document to *Populorum Progressio*. It was addressed as a letter to Cardinal Maurice Roy, president of the Council of the Laity and of the Pontifical Commission of Justice and Peace and was issued in commemoration of the eightieth anniversary of the encyclical *Rerum Novarum*, which not only became the foundation of modern Catholic social justice teachings but was a document of secular significance as well.

Like its predecessor, *Octogesima Adveniens* was particularly well-received in Latin America. It promoted subsidiarity; that is, application of the principles of *Populorum Progressio* to the local scene. It reflected Paul VI's social justice orientation and compassion, and his encouragement of proaction on the part of both the laity and local clergy. It was, literally, a call to action.

Article 11 in particular captures the influence that external factors can have on marital stability and longevity: "It is in fact the weakest who are the victims of dehumanizing living conditions, degrading for conscience and harmful for the family institution. The promiscuity of working people's housing makes a minimum of intimacy impossible; young couples waiting in vain for a decent dwelling at a price they can afford are demoralized and their union can thereby even be endangered; youth escape from a home which is too confined and seek in the streets compensations and companionships which cannot be supervised. It is

the grave duty of those responsible to strive to control this process and to give it direction."

It is significant that the pope who affirmed stringent moral demands with respect to marital chastity and self-control was consistent in insisting that couples should have humane living conditions in which to practice such. Marital spirituality and stability is not just a matter for couples but for the community as well.

Paul VI rightly points out that when basic needs are deprived, a marriage can be imperiled. When multiple stressors come into play (e.g., personal and family health problems, un/underemployment, infertility), the couple can easily enter a crisis. Nowadays with all the trendy pop psychology (co-dependency, enabling, cycle of violence, etc.) bandied about and often misunderstood and misapplied, venerable biblical and moral principles can become obscured, thereby further undermining a couple's foundation. Competent help in accordance with Christian principles can be difficult to find. Paul VI recognized these impoverishments and encouraged the faithful to seek constructive change as a society rather than tolerate unacceptable conditions.

Sacramental Reform

Beginning with the revision of the order of the Mass, Paul VI was busy with sacramental reform and the ongoing implementation of conciliar directives. Beginning with the end so to speak, the changes with regards to what used to be known as "Last rites" or "Extreme Unction" are almost undeniably positive. Like anything, the new flexibility can be abused, but even the name "Anointing of the Sick" is more biblical and pastoral. Many Catholics have been blessed to receive the sacrament even in circumstances in which they are not at the point of death.

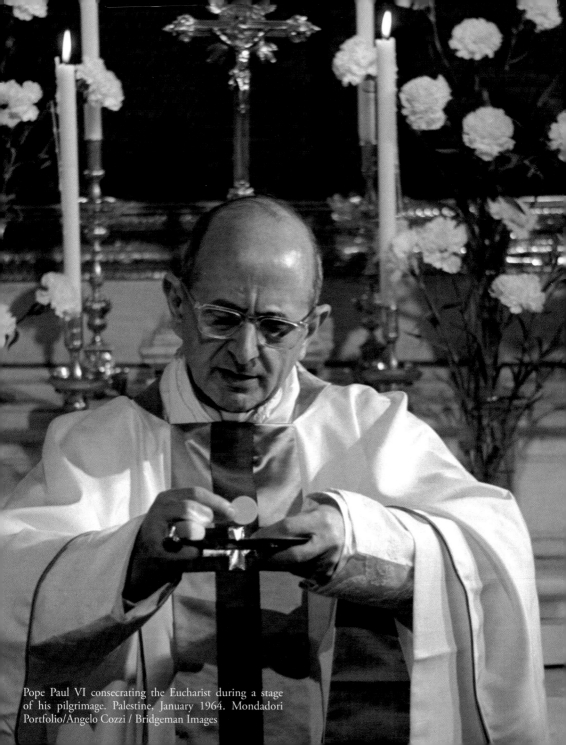

Pope Paul VI consecrating the Eucharist during a stage of his pilgrimage. Palestine, January 1964. Mondadori Portfolio/Angelo Cozzi / Bridgeman Images

Paradoxically, or not as some may argue, it is the sacrament that underwent the most fundamental innovation that has also fallen into the most tragic disuse. The decision to allow face-to-face confession, though perhaps not realized by many younger Catholics, was a profound and fundamental change. Many Catholics today prefer, perhaps even to the point of insistence, a face-to-face encounter. Those who prefer anonymity retain that option, or should. If they do not, that is the fault of the individual priest, not Paul VI. The seal of the confessional remains fully intact either way.

The words of absolution are theologically profound and personally soothing, and the introduction of a few lines from Scripture to begin the sacrament in a prayerful manner is also a welcome addition.

Confession has fallen into disuse for a number of reasons. First, the declining awareness of sin. Second, the pace and clutter of modern life. Third, its limited availability in some parishes. Sadly, today, it is all too often the case that parish priests don't encourage or facilitate it. In any event, it is difficult to see how the renewal of the rite has contributed to this lethargy. Other factors have to be involved.

Permit me to share an application of the rite popularized by Cardinal Martini, a controversial figure no doubt, and Pope Paul's successor once removed at the see of Milan. As rector of the Pontifical Biblical Institute and chancellor of the Gregorian University, Cardinal Martini had an ongoing relationship with Pope Paul VI, and in fact gave the Lenten curia retreat the year Paul VI died. His fond recollections are in his foreword to Monsignor Macchi's memoirs, *Paul VI: The Man and His Message.*

The penitent begins with a confession of praise (*confessio laudis*), sharing with the confessor what he or she is thankful for. Beginning with

praise is always a good idea in the context of prayer, especially when the content of the conversation might be painful or embarrassing. Psychologically and theologically, a hopeful foundation and orientation is wise and healthy, albeit challenging during difficult times.

From the beginning to the conclusion of the sacrament, the emphasis changes from our sinfulness to God's mercy. Plus, we put our sins in perspective. All is not lost, and we have likely made some progress, however minute perhaps. And, of course, God has done great things for us, even if we acknowledge this grudgingly amid our sorrows and disappointments.

A good confessor will be edified and receptive to this. After all, we are *celebrating* the sacrament. Thanking God and identifying the good things in our lives is a healthy stimulant to Christian joy. Confession can serve as a periodic sacramental reminder that for all its sorrows, life has some redeeming features.

The next stage is the traditional recounting of sins (*confessio vitae*), which is referred to as the confession of life. We free ourselves of the weight we are carrying, we unload and share our burden. We give an accounting to the priest in anticipation of God's mercy and forgiveness.

When Protestants tell me that they can tell their sins directly to God, I respond that I can too, but when I hurt someone, God wants me to reconcile with them directly when possible and seek to make appropriate reparation. I also may need an objective person to share my story with, protected and enriched by the graces of the sacrament and the ministry of the Church. When I sin against someone in the body of Christ, the Church suffers, and thereby can act as an appropriate intermediary.

After sharing with the priest our state in life, we then move to the concluding confession of faith (*confessio fidei*), whereby we acknowledge our trust in God's mercy. This is part of the act of contrition as well. We

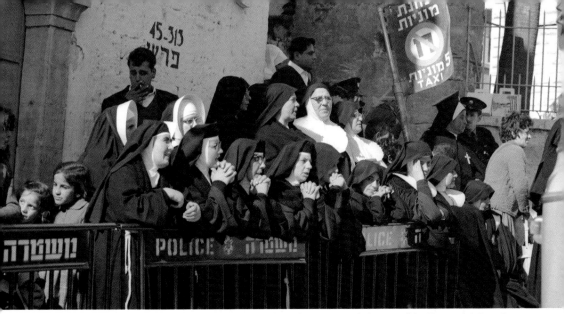

Believers waiting for Pope Paul VI, 1964 (b/w photo) / Mondadori Portfolio/Sergio del Grande / Bridgeman Images.

say we're sorry and ask for forgiveness in a spirit of trust. We end as we began, with the focus on God and the priority of grace. The new rite of confession can accommodate this holistic approach, and once again we are indebted to Paul VI for authorizing the change.

Of course, none of this is a departure from Tradition, but rather a fulfillment or progressive application and deepening development. Biblical and Catholic faith is dynamic and forward-looking rather than static and regressive.

Religious Life

On June 29, 1971, Paul issued an apostolic exhortation entitled *Evangelica Testificatio*, "On the Renewal of the Religious Life According to the Teaching of the Second Vatican Council." Laypersons can benefit from the pope's thorough reflections on the challenge of religious life in the wake of the Vatican II reforms and the increasing secularization

of the culture. It reads like a personal letter to religious with helpful reminders of the biblical underpinnings of their vocation. It explores the evangelical lifestyle from various angles and imparts a balanced spirituality capable of navigating the various challenges that confront religious in the modern world and Church. Paul VI had a deep affection for religious and was deeply hurt by the many laicizations that he approved.

His insights into the religious life have been embraced and developed in subsequent magisterial documents and allocutions. The 1971 synod did so with respect to the ministerial priesthood and justice in the world. In the 1994 synod entitled "The Consecrated Life and its Role in the Church and the World," and in the ensuing apostolic exhortation by St. John Paul VI, *Via Consecrata* (March 25, 1996), the subject was revisited with frequent references to *Evangelica Testificatio*. This is yet another area in which Paul's perspective proved prophetic, though few paid attention and recognized such at the time.

Orthodoxy Concerns

In 1973, the Sacred Congregation for the Doctrine of the Faith published a more general follow-up to *Mysterium Fidei* entitled *Mysterium Ecclesiae*. It was designed to correct influential theological opinions (primarily by a handful of controversial theologians) of questionable orthodoxy that were trickling down to the parish level.

However, its reactionary nature was also accompanied by a didactic clarification of the dynamic and contextual nature of Church teaching. Biblical scholars such as Fr. Raymond E. Brown, SS, noted that the principle of cultural conditioning and historical context that had been incorporated into biblical studies was now also being recognized as a dimension of Church teaching. The deposit of faith, however timeless, is

not static and it unfolds and develops progressively in distinct historical and ecclesiastical contexts. This recognition was part of St. John XXIII's concept of *aggiornamento,* or updating, and is implicit in Paul's 1968 *Credo of the People of God.*

Mysterium Ecclesiae articulated this dynamic understanding, thereby helping orthodox theologians and biblical scholars to bring the deposit of faith to the people of today in a comprehensible way. It also acknowledged that the principle of the development of revelation within the Bible also applied to Church teaching, not in the sense of making it vulnerable to undermining or facile change, but rather so that we recognize the Spirit at work in deepening our understanding, appropriation, and application of the message. One of the primary functions of the magisterium is to discern these issues and offer orthodox and upbuilding interpretations and applications for the faithful.

One interesting aspect of the papacy is that even the less savory inhabitants of the throne did not proclaim harmful doctrines or damage the deposit of faith. Sinfulness and misjudgments may have abounded, but the core of the deposit of faith remained unscathed. Concepts and expressions evolve in the Church as they do in the Bible, and this document was invaluable for articulating this in a lucid and prudent manner. Theologians, biblical scholars, and teachers and catechists would benefit from the thoughtful guidelines and directives published by the Church.

In hindsight, it is understandable and even predictable that after Vatican II there would be a pushing of the envelope in sensitive and subjective areas such as liturgy, moral theology, ecumenical relations, and biblical studies. A contrast can and should be drawn between the boundary-pushers who submitted to Church oversight and authority and those who did not.

Temporal Concern

27. We confess that the Kingdom of God begun here below in the Church of Christ is not of this world whose form is passing, and that its proper growth cannot be confounded with the progress of civilization, of science or of human technology, but that it consists in an ever more profound knowledge of the unfathomable riches of Christ, an ever stronger hope in eternal blessings, an ever more ardent response to the love of God, and an ever more generous bestowal of grace and holiness among men. But it is this same love which induces the Church to concern herself constantly about the true temporal welfare of men. Without ceasing to recall to her children that they have not here a lasting dwelling, she also urges them to contribute, each according to his vocation and his means, to the welfare of their earthly city, to promote justice, peace and brotherhood among men, to give their aid freely to their brothers, especially to the poorest and most unfortunate. The deep solicitude of the Church, the Spouse of Christ, for the needs of men, for their joys and hopes, their griefs and efforts, is therefore nothing other than her great desire to be present to them, in order to illuminate them with the light of Christ and to gather them all in Him, their only Savior. This solicitude can never mean that the Church conform herself to the things of this world, or that she lessen the ardor of her expectation of her Lord and of the eternal Kingdom.

28. We believe in the life eternal. We believe that the souls of all those who die in the grace of Christ whether they must still be purified in purgatory, or whether from the moment they leave their bodies Jesus takes them

to paradise as He did for the Good Thief are the People of God in the eternity beyond death, which will be finally conquered on the day of the Resurrection when these souls will be reunited with their bodies.

Prospect of Resurrection

29. We believe that the multitude of those gathered around Jesus and Mary in paradise forms the Church of Heaven where in eternal beatitude they see God as He is [Cf. 1 Jn. 3:2; Dz.-Sch. 1000], and where they also, in different degrees, are associated with the holy angels in the divine rule exercised by Christ in glory, interceding for us and helping our weakness by their brotherly care [Cf. Lumen Gentium, 49].

30. We believe in the communion of all the faithful of Christ, those who are pilgrims on earth, the dead who are attaining their purification, and the blessed in heaven, all together forming one Church; and we believe that in this communion the merciful love of God and His saints is ever listening to our prayers, as Jesus told us: Ask and you will receive [Cf. Lk. 10:9-10; Jn. 16:24]. Thus it is with faith and in hope that we look forward to the resurrection of the dead, and the life of the world to come.

Blessed be God Thrice Holy. Amen.

—Paul VI

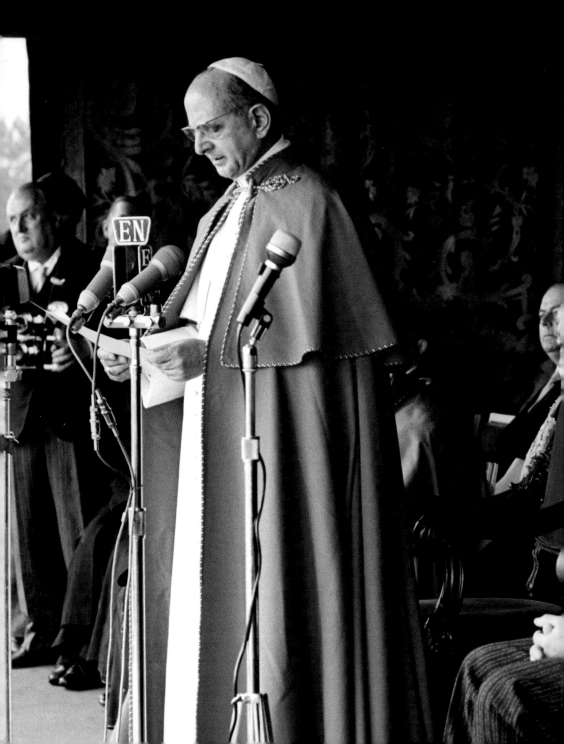

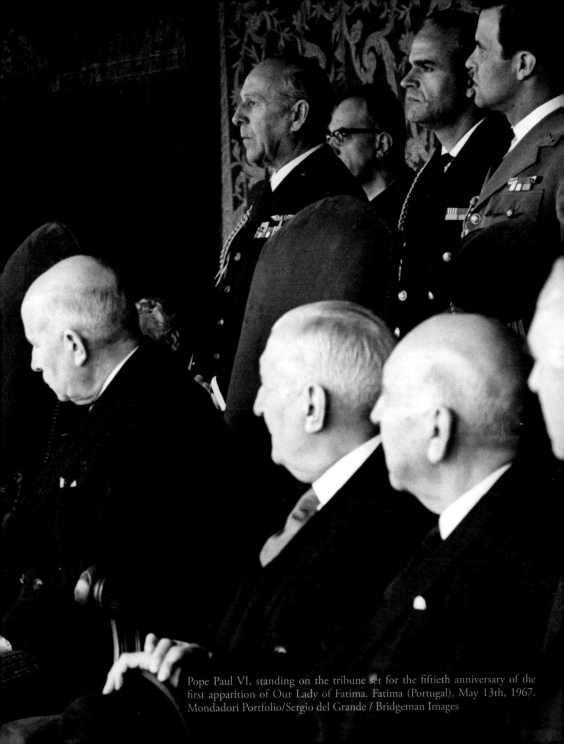

Pope Paul VI, standing on the tribune set for the fiftieth anniversary of the first apparition of Our Lady of Fatima. Fatima (Portugal), May 13th, 1967. Mondadori Portfolio/Sergio del Grande / Bridgeman Images

Mary

On February 2, 1974, Paul VI issued one of the finest modern magisterial documents on Marian devotions. Entitled *Marialis Cultus*, "For the Right Ordering and Development of Devotion to the Blessed Virgin Mary," the apostolic exhortation addressed an important need within the Church for clarity on a subject that had receded and undergone an unforeseen de-prioritization in the aftermath of the council.

Its breadth, clarity, and pastoral acuity makes for a stimulating read, and its biblical core and balanced, judicious reasoning make it the Marian document most comprehensible and agreeable for Protestants. It is like a mini-course in basic Marian spirituality and devotional practices. Section 57 contains one of the finest concise syntheses of biblical teaching on Mary available, constituting a veritable and inspired lectio divina resource on the Blessed Mother:

> The Blessed Virgin's exemplary holiness encourages the faithful to "raise their eyes to Mary who shines forth before the whole community of the elect as a model of the virtues." It is a question of solid, evangelical virtues: faith and the docile acceptance of the Word of God (cf. Lk. 1:26-38, 1:45, 11:27-28; Jn. 2:5); generous obedience (cf. Lk. 1:38); genuine humility (cf. Lk. 1:48); solicitous charity (cf. Lk. 1:39-56); profound wisdom (cf. Lk. 1:29, 34; 2:19, 33:51); worship of God manifested in alacrity in the fulfillment of religious duties (cf. Lk. 2:21-41), in gratitude for gifts received (cf. Lk. 1:46-49), in her offering in the Temple (cf. Lk. 2:22-24) and in her prayer in the midst of the apostolic community (cf. Acts 1:12-14); her fortitude in exile (cf. Mt. 2:13-23) and in suffering

(cf. Lk. 2:34-35, 49; Jn. 19 25); her poverty reflecting dignity and trust in God (cf. Lk. 1:48, 2:24) her attentive care for her Son, from His humble birth to the ignominy of the cross (cf. Lk. 2:1-7; Jn. 19:25-27); her delicate forethought (cf. Jn. 2:1-11); her virginal purity (cf. Mt. 1:18-25; Lk. 1:26-38); her strong and chaste married love. These virtues of the Mother will also adorn her children who steadfastly study her example in order to reflect it in their own lives. And this progress in virtue will appear as the consequence and the already mature fruit of that pastoral zeal which springs from devotion to the Blessed Virgin.

In section 35, Paul captures the essence of the Virgin's virtues:

First, the Virgin Mary has always been proposed to the faithful by the Church as an example to be imitated, not precisely in the type of life she led, and much less for the socio-cultural background in which she lived and which today scarcely exists anywhere. She is held up as an example to the faithful rather for the way in which, in her own particular life, she fully and responsibly accepted the will of God (cf. Lk. 1:38), because she heard the word of God and acted on it, and because charity and a spirit of service were the driving force of her actions. She is worthy of imitation because she was the first and the most perfect of Christ's disciples. All of this has a permanent and universal exemplary value.

Paul had issued two previous encyclicals on Mary that primarily dealt with devotions to her in the months of May and October, and he had

proclaimed her Mother of the Church at the conclusion of the second session of the council, on November 21, 1964, so his attentiveness to this pastoral need was consistent throughout his papacy.

For persons wishing to begin a path of Marian devotion or reacquaint themselves with such, it would be difficult to find a better starting point than this document issued by our newest papal saint.

Reconciliation

On December 8, 1974, Paul VI published another apostolic exhortation, *Paterna cum benevolentia,* "On Reconciliation in the Church." Once again, following in the footsteps of *Mysterium Ecclesiae,* the pope deemed it necessary to address the turmoil and confusion within the Church in a constructive and proactive manner, in hopes of greater clarity and unity. Paul VI disliked heavy-handed measures, and personally and ministerially practiced one of the great themes of his papacy: "Reconciliation is the Way to Peace."

A Reason to Rejoice

1975 was a Jubilee Year that touched Paul VI deeply. It was a busy year for a pope written off by many as past his prime. Monsignor Macchi reports in *Paul VI: The Man and His Message* that the night on which the Holy Gate was opened brought so much joy to Paul VI that he was inspired to write an encyclical.

On May 9, 1975, this took the form of an apostolic exhortation entitled *Gaudete in Domini,* "On Christian Joy." It passed under the radar at the time but is regarded by informed commentators on Paul VI as under-appreciated and highly representative of his outlook and spirituality. Its authenticity comes across because the pope lived it.

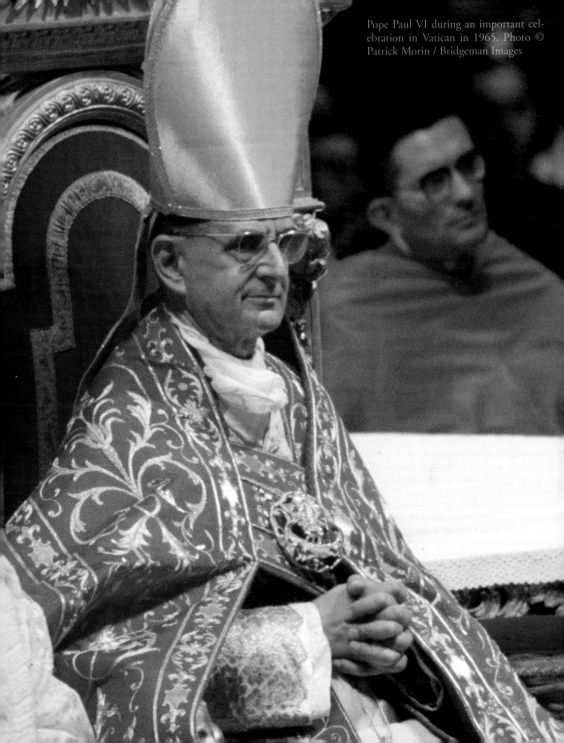

Because Paul VI was such an insightful reader of the signs of the times, and an astute observer of the modern world enlightened by over four decades of service to the Church and the world, he was able to identify the levels and parameters of evangelization, measure the depth of its core substance and meaning, and contemplatively articulate its proper expression in the secularized and polarized Church and world of today.

It is a testimony to Paul's magnanimity that he was able to respond so affectionately and prophetically to the world and Church, each of which had caused him grief and disappointment in different ways. Instead of thumbing his nose and going into a shell, he reflected and produced what some consider a masterpiece that complemented and consummated his original vision for the council and his papacy as articulated in his first encyclical, *Ecclesiam Suam.*

A Magisterial Coup de Grace

Ever the diplomat and apostle, in the footsteps of his namesake, Paul VI's last major document was a fitting epitaph to his papacy. Awareness (conscientiousness), renewal, and dialogue is essential to the well-being of the Church. These qualities cannot remain inward, but rather must manifest themselves to the world in evangelical openness and fervor, recognizing that the message we have is not ours to cling to in a proud, possessive way. Faith is a gift to be shared. Evangelists are those who themselves are being evangelized and are available to help others receive and live the Gospel.

Paul VI ended on a high note, fully in sync with a council that sought to reach out to a changing world that was gradually, and in some instances radically, turning away from Judeo-Christian values and toward hedonistic materialism. Paul VI refused to be discouraged for long, no

matter how daunting the obstacle or rejection, and faithfully handed on the message entrusted to him as vicar of Christ. Toward the midpoint of his papacy, Paul VI had come to grips with the drama in which he was participating, taking on the characteristics of a tragedy one moment and a divine comedy the next. On November 18, 1970, he observed: "Our journey is chiefly meant to be a meeting, a human and spiritual meeting among persons who already know each other, who understand each other deeply and who love each other. We can call it a meeting among Brethren. Is not the Church a fraternity? (cf. Rom 12:10; 1 Th 4:9; 1 Pet 2:17; 1 Pet 5:9, etc.)."

Yes, a dialogue, a bringing together and unification of the Church, but not as a self-absorbed, self-contained unit. No, rather as pilgrims on a journey like the Hebrews in the desert, recalling an image he had invoked earlier in his papacy:

> In the pope's life there are no times of rest or respite. Fatherhood is never suspended. And since what he is dealing with always goes beyond the bounds of possibility, the only solution he has is to abandon himself to the present moment, which is the Lord. A pope lives from crisis to crisis, from moment to moment. He goes, like the Hebrews in the desert, from manna to manna. And he has not much time to look back on the road he has traveled, or forward to the way that lies ahead.

A week later, reflecting further on his papal vocation (as the "strengthener of the brethren" and "the servant of the servants of God") and situation, he posited:

He is small, like an ant, weak, unarmed, as tiny as a *quantite negligeable*. He tries to make his way through the throng of peoples; he is trying to say something.

He becomes unyielding, and tries to make himself heard; he assumes the appearance of a teacher, a prophet. He assures them that what he is saying does not come from himself, but is a secret and infallible word, a word with a thousand echoes, resounding in the thousand languages of mankind. But what strikes us most in the comparison we make between the personage and his surroundings, is disproportion: in number, in quality, in power, in means, in topicality. . . . But that little man—you will have guessed who he is: the apostle, the messenger of the Gospel—is the witness. In this case it is the Pope, daring to pit himself against mankind. David and Goliath? Others will say Don Quixote. . . . A scene irrelevant, outmoded, embarrassing, dangerous, ridiculous. This is what one hears said: and the appearances seem to justify these comments. [cf. Is 53:2, the unsightly suffering servant—Ed.]

But, when he manages to obtain a little silence and attract a listener, the little man speaks in a tone of certainty which is all his own. He utters inconceivable things, mysteries of an invisible world which is yet near us, the divine world, the Christian world, but mysteries. . . .

Some laugh; others say to him: we will hear you another time, as they said to Saint Paul in the Areopagus at Athens (Acts 17:32-33).

However, someone there has listened, and always listens, and has perceived that in that plaintive but assured voice there

can be distinguished two singular and most sweet accents, which resound wonderfully in the depths of their spirits: one is the accent of truth and the other is the accent of love. They perceive that the word is the speaker's only in the sense that he is an instrument: it is a Word in its own right, the Word of Another. Where was that Other, and where is He now? He could not and cannot be other than a living Being, a Person who is essentially a Word, a Word made man, the Word of God.

. . . Oh Christ, is it You? You, the Truth? You, Love? Are you here, here with us? In this so much developed, so confused world? This world so corrupt and cruel when it decides to be content with itself, and so innocent and so lovable when it is evangelically childlike?

This world, so intelligent, but so profane, and often deliberately blind and deaf to Your signs? This world which You, fountain of Love, loved unto death; You, who revealed yourself in Love? You, salvation, You the joy of the human race. You are here with the Church, Your sacrament and instrument (cf. Lumen Gentium, 1:48; Gaudium et Spes, 45). Does it proclaim you and convey you?

This is the perennial drama which develops over the centuries, and which finds in our journey an instant of indescribable reality. Let us spiritually take part in it all together, dearest Brethren and children.

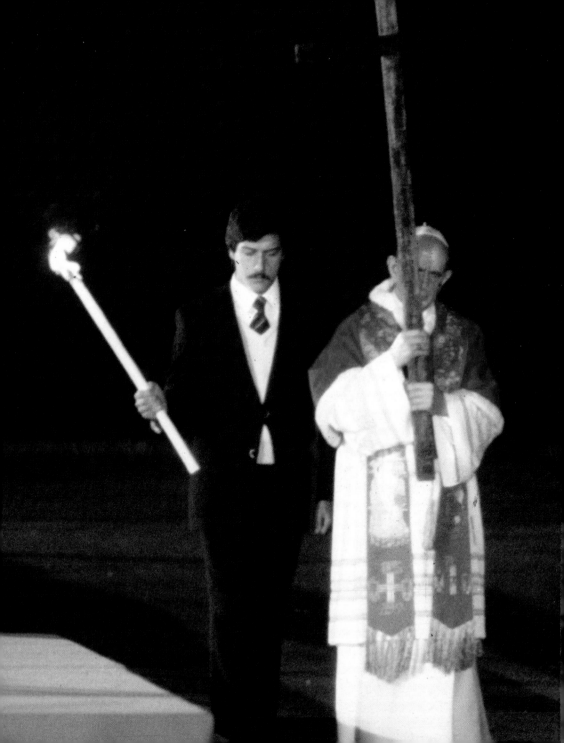

Pope Paul VI with a wood cross for Easter Mass on April 20, 1976 in Rome. Photo © Patrick Morin / Bridgeman Images

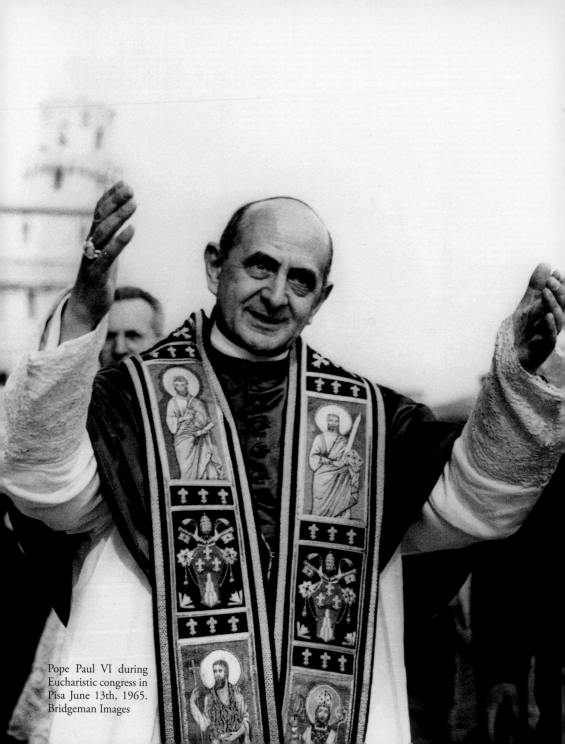

Pope Paul VI during
Eucharistic congress in
Pisa June 13th, 1965.
Bridgeman Images

Paul's Times and Legacy

In order to get a true grasp of Paul VI's pontificate, we have to consider the environment in which he reigned. He became pope on June 21, 1963, several months after the first session of the council had ended. Less than a year before, the Cuban missile crisis had the world on the brink of nuclear war for thirteen days. St. John XXIII himself intervened. The world held its collective breath as the two superpowers engaged in a tug of war that was resolved by the kind of diplomacy that Paul VI would appreciate.

South Vietnam was in a state of political turmoil, with their leader, Diem, on the brink of overthrow and assassination (November 2, 1963). A mere twenty days after the killing of Diem, John F. Kennedy, America's first and still only Catholic president, was himself murdered on the streets of Dallas, Texas.

Beatlemania was sweeping Britain but had yet to hit America. The youth culture was beginning to emerge and gradually its dark side of celebrity worship, promiscuity, and substance abuse would manifest itself.

The most tumultuous year in Paul's papacy, 1968, was also the most turbulent politically and socially in modern times. The issuance

of *Humanae Vitae* triggered a firestorm of protests and derision that was exacerbated by unrealistic expectations generated by media and activist hype.

Paul had given no indications that he was leaning toward changing Catholic teaching on contraception. He was studying it. After all, fewer than forty years prior to the encyclical's release, all major Christian denominations had forbidden contraception. The premature leaking of the findings of the birth control commission had artificially raised expectations and evoked false hopes that Paul, himself, had done little to encourage.

Conversely, economic pressures were considerable on families, and there could be health and marital stability considerations as well. Paul VI understood all this, and thus he looked into the issue exhaustively, summoning experts and evidence from various fields in order to make an informed and prudent decision.

Politically, 1968 was the year of the earth-shaking assassinations: the deaths of Reverend Martin Luther King, Jr. and Senator Robert F. Kennedy changed the political landscape and triggered riots and protests that gave the appearance of a country coming apart at the seams. Violent student protests were erupting all over Europe, particularly in Germany, and campus unrest was rampant in the United States.

Riots in the wake of King's assassination and at the Democratic convention captured the headlines, but many other social changes were occurring. The drug culture was now in full swing. Iconic figures such as the Beatles, Timothy Leary, and Andy Warhol were contributing to the evolution of pop culture in a direction incompatible with traditional Christian values. The Tet Offensive revealed that the Vietnam War was not drawing closer to a resolution. The American space program was

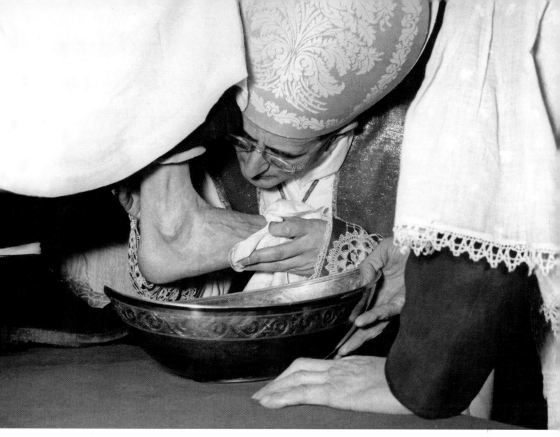

Archbishop of Milan Giovanni Battista Montini (future Pope Paul VI) during washing of feet on March 29th, 1956 in Milan's Cathedral

on the brink of landing a man on the moon. The women's movement was becoming more militant as it attained social and political influence. Its moderate and dialogical elements were being drowned out by the bra-burning extremists, a tyranny of the minority that continues to oppose the "active collaboration" mentality proposed by the Church as an alternative to gender strife and adversarialism.

So much transpired in 1968 that in early January 2018, the American Historical Association's annual meeting commemorated the fiftieth anniversary of that turbulent year, and over 1,500 historians gathered to

look back and assess what happened and why, and its relevance to the current situation.

Amid such dramatic and far-reaching change, Paul VI had a whirl-wind-like revolution of his own to contend with, that of the implementation of the Vatican Council. By that time, questionable interpretations and adaptations had begun to manifest themselves, with avant-garde experimentation with the liturgy soon to follow.

Misunderstandings of Paul's Temperament and Leadership Style

This brief recollection of his times reminds us that Paul VI did not teach and lead in a vacuum. His sensitivity to the modern spirit and his acute insight into human nature made him very cognizant of the implications of the issues facing the Church, and he always approached them in a deliberate and measured manner, causing him to be stereotyped as an indecisive, Hamlet-like leader.

In the estimation of this writer, this evaluation was and remains unfair and misleading because an intelligent and caring person with great responsibilities naturally wants to consider all angles and potential consequences in order to make a decision in accordance with the common good. Paul VI did not seal himself off from others, even those opposed to him. He was willing to listen and consider discordant viewpoints, and he was diligent about consulting experts in multiple disciplines and availing himself of the best research. Given his experience, temperament, and outlook, the outcomes were invariably progressive and moderate, never static or regressive, and always in line with the traditional middle path of Catholicism and human virtue.

This innate tendency toward moderation invariably drew the ire of extremists on both ends, and together with his reserved public persona

resulted in him being overshadowed very quickly by St. John Paul II, the first non-Italian pope in centuries and one around whom, unsurprisingly given his charisma and vigorous orthodoxy, a cult of personality developed unlike anything seen in recent Church history.

People who pursue a middle path inevitably alienate many. When sensitive subjects are in play and Christian and secular values are in direct opposition, those who opt for charitable reasonableness and integrity typically satisfy only a discerning minority; that is, centrist persons who recognize the complexity of circumstances and admire someone who strives to balance the needs and interests of all.

Paul the Unifier

Like Leo I and Gregory I, St. Paul VI held the Church together amid a cacophony of forces seeking to tear it apart, while simultaneously contributing to its reform and the development of its doctrine, culture, and spirituality. Given the forces at play, it is remarkable that the Church did not polarize more than it did during his reign.

Paul's Legacy

While tensions and confusion abounded during Paul's papacy and abuses occurred, the changes inaugurated by the council began to take hold, evolve, and eventually stabilize, and many positive consequences ensued. The biblical and ecumenical movements flourished. In 1969, Paul founded the Catholic Biblical Federation, which promoted biblical study, spirituality, and ministry at the pastoral level. Aberrations occurred at times, but this is inevitable with such developments. Mass became much more participatory. Many Catholics were reminded of the universal call to holiness. The laity gained prominence without

encroaching upon the priesthood, in part because Paul VI frequently reminded clergy and religious not to act like laypersons, and thereby blur vocational distinctions. Religious life had a shakeout, but stabilized.

Continuity

Often lost in the shuffle is the significant gesture of John Paul I in taking the names of his two immediate predecessors who were perceived so differently by the public. This gesture was a public affirmation of the leadership, mindset, and direction expressed in the council and its aftermath, and later by his successors. St. John XXIII may have inaugurated reforms in the Church, but Paul VI kept them on track and brought them to fruition. Both popes were peacemakers, and the Church increasingly became a force for peace in the world. The Church came out of its post-Reformation and post-modernist period and embraced the world, risking the very rejection that in many ways ensued.

To the end of his papacy, Paul VI held on to the deposit of faith without insulating it from natural and beneficial changes. It is true that the Church under Paul VI endured many pains and diversions and occasional regressions. A lot of pruning and re-evaluation is necessary, but there is no turning back, as Benedict XVI has so eloquently affirmed.

St. Paul VI was, perhaps arguably, but certainly in the opinion of this writer, a great pope, but he was an even greater Christian. Perhaps no one recognized this as directly as the leaders of the Orthodox Church with whom he collaborated to heal a thousand-year wound. Several of them made comments with respect to Paul's sanctity, humanity, and rich personality that proved capable of mending fences and exploring frontiers, but always with the deposit of the faith in mind.

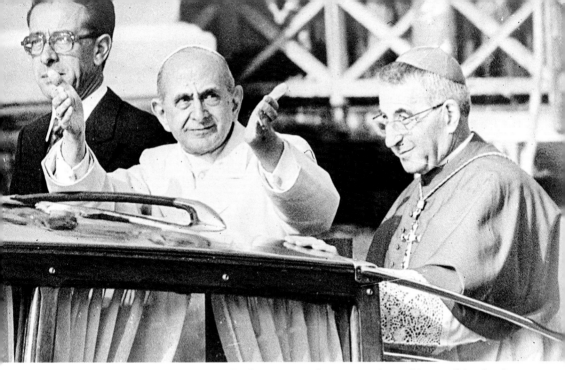

Pope Paul VI visiting Venice, with Albino Luciani, future Pope John Paul I, 1972 (b/w photo), Italian photographer, (20th century) / Alinari / Bridgeman Images

Paul, Prophet and Evangelizer

In his memorable November 25, 1970 address with which the previous section closed, Paul VI prophetically asserted that someone always listens to the voice of Peter and the Spirit. Yes, Pope St. Paul, like the risen Lord ministering to the bewildered believers both individually and collectively, the work of evangelization goes on and on. The Lord is as concerned for the lost sheep as for those who remain in the pasture. Evangelization is not a numbers game, but an exchange between brothers and sisters.

Long live the memory of St. Paul VI, who not only held us together, but helped us rediscover our identity and, most importantly, grow closer to Christ and each other, and, in the proper dimension, the world. His

patience and prophetic wisdom have borne fruit, if only belatedly, in the reclamation of his memory and its rightful restoration to prominence in the Church's consciousness and conscientiousness, which for many fond admirers he always had. We now celebrate the Church's proclamation of his presence in heaven. May his shining example inspire and motivate us to persevere in the Church's mission to foster peace and together build a civilization of love.

Pope St. Paul VI, pray for us!

(*opposite*) Pope Paul VI during Mass in 1976 / photo © Patrick Morin / Bridgeman Images

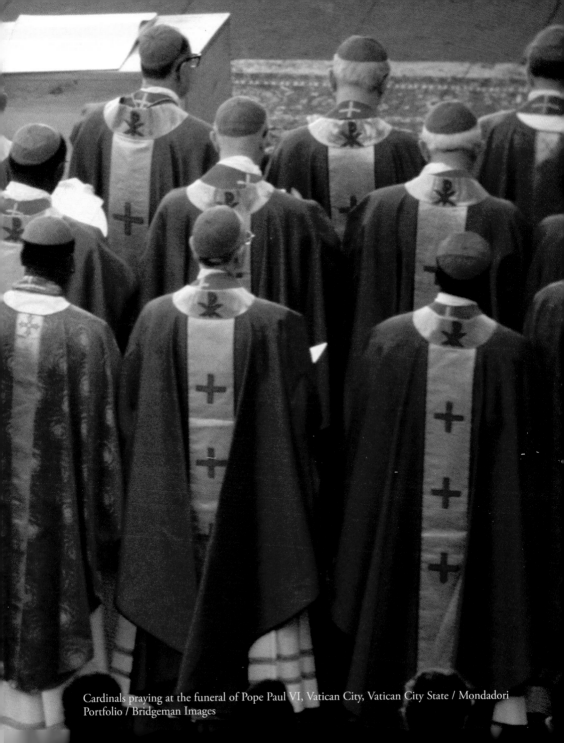

Cardinals praying at the funeral of Pope Paul VI, Vatican City, Vatican City State / Mondadori Portfolio / Bridgeman Images

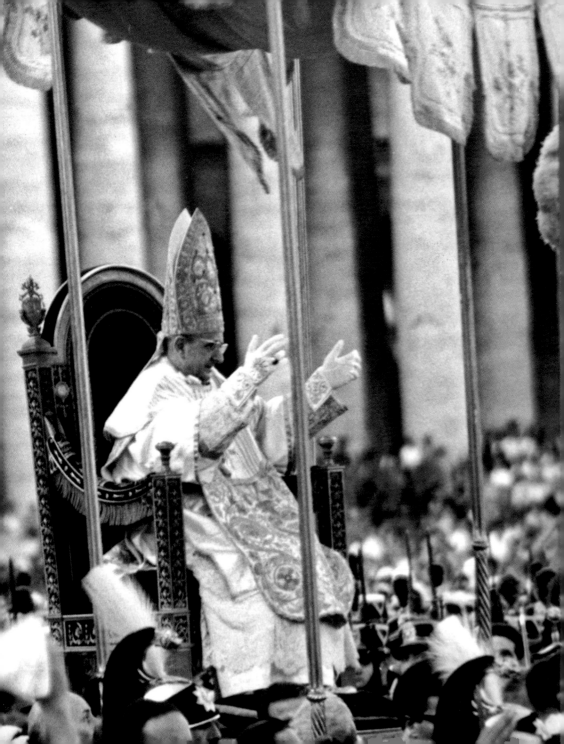

Bibliography

1. Andrews, James F., ed. *Paul VI: Critical Appraisals.* New York: The Bruce Publishing Company, 1970.
2. Carrier, Herve. *Gospel Message and Human Cultures: From Leo XIII to John Paul II.* Pittsburgh, PA: Duquesne University Press, 1989.
3. Collins, Michael. *Paul VI: Pilgrim Pope.* Collegeville, MN: The Liturgical Press, 2018.
4. Guitton, Jean. *The Pope Speaks: Dialogues with Paul VI.* New York: Meredith Press, 1968.
5. Hatch, Alden. *Pope Paul VI.* New York: Random House, 1966.
6. Hebblethwaite, Peter. *Paul VI: The First Modern Pope.* Mahwah, NJ: Paulist Press, 2018.
7. Macchi, Pasquale. *Paul VI: The Man and His Message.* Nairobi, Kenya: Pauline Publications Africa, 2007.
8. Schultz, Karl A. *Pope Paul VI: Christian Virtues and Values.* New York: The Crossroad Publishing Company, 2007.
9. Schultz, Karl A. *Prophet and Pilgrim of Peace: 99 Sayings by St. Paul VI.* Hyde Park, NY: New City Press, 2018.
10. United States Catholic Conference. *The Teachings of Pope Paul VI.* Washington, DC: USCC, 1968–73.

(*opposite*) Enthronement of Pope Paul VI in Rome on June 30th, 1963 / Bridgeman Images

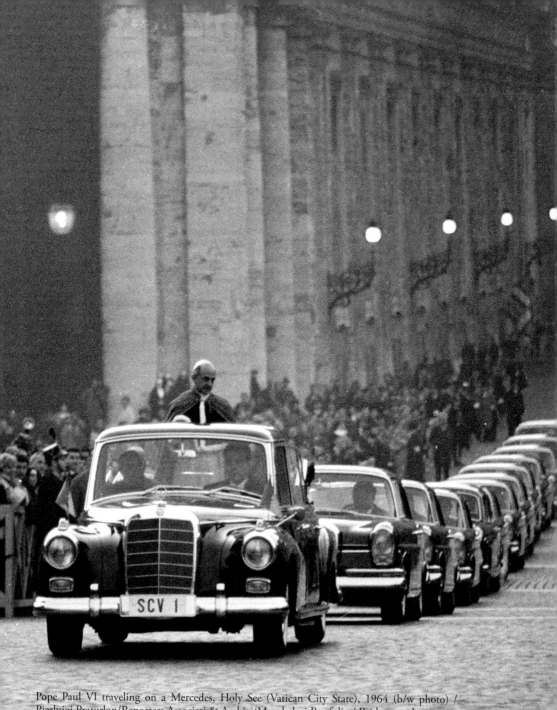

Pope Paul VI traveling on a Mercedes, Holy See (Vatican City State), 1964 (b/w photo) /
Pierluigi Praturlon/Reporters Associati & Archivi/Mondadori Portfolio / Bridgeman Images

About the Author

Few authors in the English-speaking Catholic world are better equipped to guide you through a visual tour of Paul VI's life than Karl A. Schultz. He has lectured on Pope Saint Paul VI internationally, discussed him numerous times on EWTN, and published three prior books on him, among the nearly twenty to his credit. More information on Schultz and his extensive and wide-ranging work as a Catholic author and presenter can be found at his website www.karlaschultz.com. There you can learn about the retreats, missions, workshops, and presentations he offers on lectio divina, biblical spirituality, Theology of the Body, St. Paul VI, St. Joseph, the book of Job and the story of Adam and Eve, men's and marital spirituality, and the compelling one act plays he conducts on St. Paul VI, St. John Paul II, and St. Joseph. Schultz invites reader feedback and can be contacted at karlaschultz@juno.com or by phone at (386) 323-3808. Texts can be sent to (386) 383-4402.

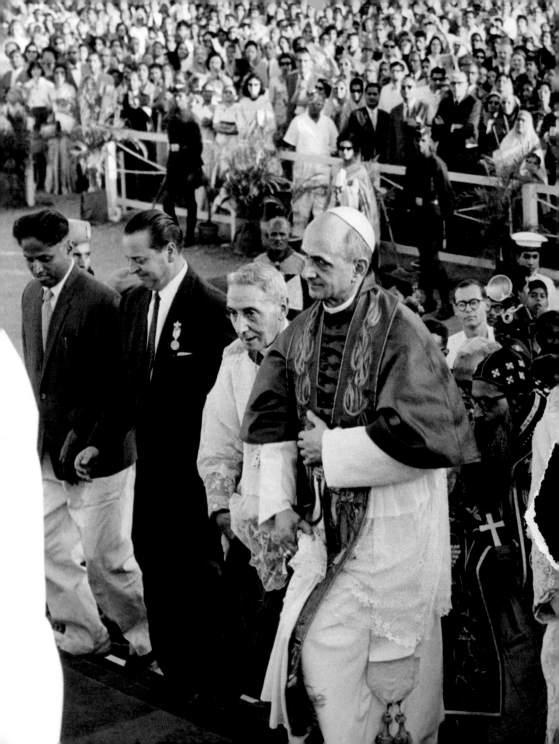